Home Front America

Home Front America

POPULAR CULTURE OF THE WORLD WAR II ERA

Robert Heide and John Gilman

CHRONICLE BOOKS

SAN FRANCISCO

[TITLE PAGE] *Khaki-colored Catalin pencil sharpener with U.S. Army tank decal applique.*

Printed in Hong Kong.
ISBN 0-8118-0927-7

Library of Congress Cataloging-in-Publication Data available.

Cover design: Elixir Design Co.
Book design and composition: Gretchen Scoble
Production: Anne Shannon
Cover photography: John Gilman

Distributed in Canada by Raincoast Books,
8680 Cambie Street
Vancouver, BC V6P 6M9

10 9 8 7 6 5 4 3 2 1

Chronicle Books
275 Fifth Street

★ ★ ★

———————————————

The authors dedicate this book to their family members
who experienced the home front during World War II:
Robert Heide to his mother Olga, father Ludwig,
sister Evelyn, and brother Walter.
John Gilman to his mother Heléne, father LaSelle,
and brother Peter.

———————————————

★ ★ ★

★ ★ ★

1] Conserve everything you use. Use less.

2] Buy only what is necessary.

3] Salvage what you do not need.

4] Share what you have.

War Conservation Message

from the OFFICE OF PRICE ADMINISTRATION

[OPA]

Table of Contents

Preface

HOME FRONT MEMENTOS

★ ★ ★

*J*UST AS WORLD WAR I veterans brought back "souvenirs" to remember the battle-fields of Europe and those on the American home front saved the memorabilia and artful poster of that "war to end all wars," so the 1940s generation kept and preserved the arti-facts and mementos of the Second World War. Now regarded as the major war of the twen-tieth century by scholars and historians, World War II, with its advanced propaganda machinery and sophisticated media developments, permeated every area of both civilian and military life. Everything from work-front "Go-to-War" and "Zip-Your-Lip" posters, special store window displays, extensive war bonds and scrap drives, and "Uncle-Sam-Wants-You!" enlistment brochures as well as a ceaseless bombardment from newspapers, magazines, product advertisements, Tin-Pan-Alley war-theme songs, wartime Hollywood movies, and special radio programming was geared toward inspiring a greater war effort.

[BELOW] *Porcelain enamel serving tray,* "Let's Go! USA." The Baltimore Enamel and Novelty Co., Baltimore, Maryland.

American citizens on the home front and in the military services felt that this war against Hitler, Mussolini, and Hirohito was a just one; their patriotic enthusiasm to fight was doubly fueled by the propaganda issued forth by the various agencies of the War Department, industry, and the private sector. Women donned overalls and went to work in the defense plants, replacing the men who had joined the Army, Navy, or Marines. These same women preferred slacks or pantsuits to dresses for leisure time, leading a more masculine fashion trend that went along with the responsibility of doing a man's job. Even though women gave up their jobs and returned to home life when the men came back from the war, they helped to open the door for the liberation of future generations of women.

The 1940s war years and the immediate post-war period now evoke a powerful nostalgia for most Americans who remember it as a time when their country was filled with a fighting

spirit of togetherness and a forward-looking hope for a better future. Pre-war futuristic "World of Tomorrow" plans had been laid forth at the World's Fairs of 1939 and 1940 in New York and San Francisco including scarab-shaped automobiles, streamlined locomotives, electric dishwashers, television sets, and superhighways.

Today at military shows, antique shows, and flea markets, World War II home front mementos are increasingly displayed: flags; servicemens' home-window banners; souvenir war pennants; "mother, sister, sweetheart" or "to-my-wife" satin pillowcases; pseudo-military dimestore jewelry; ration books; stamps and tokens; homebody scrapbooks with clippings; letters and snapshots; propaganda home front posters and war store signs; and maps and magazines. Home decorations with war-themes like "V-for-Victory" vases, bomb-shaped salt and pepper sets, wartime cookbooks, and Victory garden manuals are especially in demand.

During fiftieth anniversary celebrations of Pearl Harbor, D-Day, V-E Day and V-J Day, town halls, community centers, libraries, historical societies, and museums across America created special World War II displays and exhibitions of this memorabilia meant to re-create the lifestyles of the American World War II home front. Newspapers published facsimiles of old wartime editions and special pamphlets documented local hometown war efforts. Contained in these publications are the headlines, the features, and special war reports including the entertainment pages and advertisements of the period. The *New York Times* published a full "special" war reprint edition headlined "JAPAN WAR ON U.S. AND BRITAIN: MAKES SUDDEN ATTACK ON HAWAII: HEAVY SIGHTING AT SEA REPORTED—DECEMBER 8, 1941." The revival of the pop music of the 1940s, the big band sound made a full swing-shift turn into the 1990s to become the standard musical style of the twentieth century. The classic-pop-sounds of Tommy Dorsey, Jimmy Dorsey, Benny Goodman, Glenn Miller, Sammy Kaye, Glen Gray, and Harry James orchestras and forties vocalists like Frank Sinatra, Dick Haymes, Dinah Shore, Kitty Callen, Ray and Bob Eberle, Helen O' Connell, Helen Forrest, Peggy Lee, Ginny Simms, Frances Langford, Marion Hutton, Phil Brito, Jo Stafford, Andy Russell, Kate Smith and others are played again by "nostalgia" radio disc jockeys who proclaim over the airwaves, *"This is the music of your life!"* Movie videos and music recordings of the 1940s are available everywhere; and not just for those who remember or reminisce.

As the millenium approaches, World War II, American home front activities, and the souvenirs and mementos associated with it take on a greater significance, not just for those who were there but for all who know there is something to be learned in examining these artifacts.

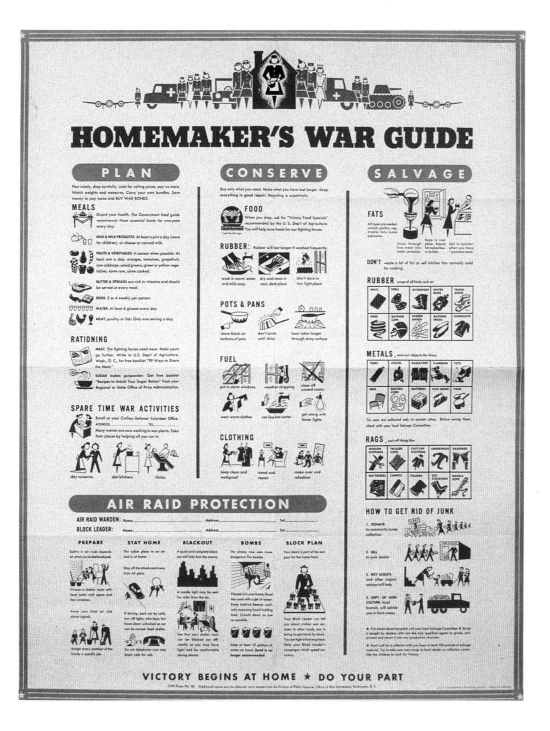

[ABOVE] *Homemaker's War Guide,* OWI Poster #20, Office of War Information.

World War II Highlights

★ ★ ★

Blitzkrieg

★ Hitler's advance into Poland: On September 1, 1939, Adolf Hitler screamed out at a huge Berlin rally, "I have put on my old soldier's coat—and it will not come off until we win victory for the Fatherland!" With arms upraised in a salute to Der Fuehrer the crowd screamed out "Sieg Heil! Sieg Heil! Sieg Heil!"

★ Following the invasion of Poland, Britain's Prime Minister Neville Chamberlain, speaking from #10 Downing Street in London on September 3, 1939, solemnly announced to the British Empire "this country is at war with Germany."

★ U.S. newspaper headlines on September 11, 1939, read:

WARSAW, 5 CITIES BOMBED!

HITLER SAYS IT'S FIGHT TO THE FINISH

POLES CALL NAZIS AGGRESSORS

ALLIES RUSH WAR MOBILIZATION

BRITAIN, FRANCE ON FULL WAR FOOTING AS EVACUATION STARTS

[ABOVE]: *"Blitzkrieg Baby (You Can't Bomb Me),"* Una Mae Carlisle with orchestra, 78 rpm Bluebird record.

★ France surrenders June 22, 1940, after a German offensive of forces joined with the Italian dictator Benito Mussolini.

★ From September 7, 1940, to May 11, 1941, London and other regions and cities in the British Isles withstood devastating aerial bombings from the night-raiding German Luftwaffe; a period that the English called "The Blitz."

Pearl Harbor

★ At 7:02 A.M. on December 7th, 1941, the U.S. Destroyer *Ward* sank a midget Japanese submarine at the entrance to Pearl Harbor, Hawaii, headquarters of the U.S. Naval Fleet and America's westernmost stronghold.

★ At 7:53 A.M., 43 Mitsubishi fighter planes and 140 Nakajima torpedo bombers and

Aichi dive bombers swooped down at Pearl Harbor and other naval and military installations on the island of Oahu, bombing, torpedoing, and straffing.

★ At 8:55 A.M., a second wave of 183 Japanese fighters and bombers struck a second time at Pearl Harbor.

★ The dead included 2,335 sailors, soldiers, and marines, and almost one hundred civilians; 1,178 were wounded, twenty-one ships including three cruisers and eight battleships were sunk or damaged, and 188 aircraft were destroyed.

★ Simultaneous attacks occurred at Guam, Wake Island, the Philippines, and other strategic points in the Pacific.

★ The United States officially declared war on Japan on December 8, 1941.

★ On December 11, the United States declared war on Germany and Italy.

War in the Pacific

★ On May 6, 1942, General Jonathan M. Wainwright surrendered the fortress at Corregidor in the Philippines to Japanese troops under General Tomoyuki Yamashita.

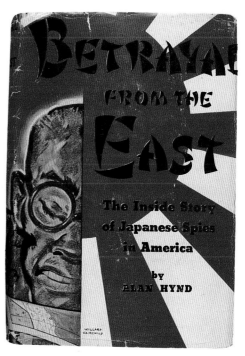

★ American and Allied raids were executed on the Marshall, Gilbert, and Marcus Islands and surprise flash attacks on Tokyo were made by Lt. Colonel James Doolittle's bombers from the aircraft carrier *Hornet*.

★ The Battle of the Coral Sea, a naval battle fought entirely with aircraft, was a major victory for the Allies in the war, costing the Japanese seven warships and one carrier.

★ Painfully hard-won Allied victories were scored at the Battle of Midway, Guadalcanal, Tarawa, Iwo Jima, Okinawa, and at the Battle of Leyte Gulf. American deaths totalled almost 13,000 at Okinawa with nearly 40,000 wounded; 100,000 Japanese soldiers were killed.

★ After being forced out of Manila by the Japanese three years earlier, General Douglas MacArthur, commander-in-chief of the Southwest Pacific

Command, kept his "I shall return" promise, taking the Leyte Peninsula in the Philippines on October 26, 1944.

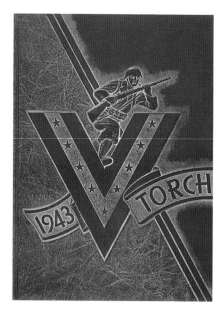

[ABOVE] *1943 Torch Yearbook from the all-black Sterling High School, Greenville, South Carolina,* dedicated to its graduate members in the service.

The European Front

★ In July of 1943 the Allies invaded Sicily, which surrendered on September 30, 1943.

★ On December 24, 1943, General Dwight D. Eisenhower was chosen Supreme Commander of the Allied Expeditionary Forces, declaring that the time had arrived for land, sea, and air attacks in Europe, stating to the Allies, "Now, if you see fighter aircraft in the skies overhead, they will be ours."

★ Great Britain and the United States suffered great losses in the air war against Germany: 18,500 Allied bombers and fighters and 64,000 airmen were lost to the Luftwaffe and in anti-aircraft attacks. But the war by air took a turnabout in early 1944 when the United States home front factory workers delivered the first invincible fleets of Liberator bombers and "Flying Fortresses." German cities were destroyed and the powerful Luftwaffe was obliterated.

D-Day

★ June 6, 1944, otherwise known as D-Day, involved an all-out attack against the enemy with three million fighting men, 16 tons of arms, 5,000 ships, 4,000 landing craft, and 11,000 planes under the combined Allied leadership of Dwight D. Eisenhower, Field Marshall Viscount Bernard Montgomery, Lt. General Omar Bradley, Lt. General Sir Miles C. Dempsey, General H. Crerar, and Lt. General William H. Simpson. Sea landings were made at Utah, Omaha, Gold, Juno, and Sword (Allied code names for France's Normandy coast beaches) and although enormous losses were sustained in terms of manpower and equipment, the invasion was successful and the German lines collapsed.

Liberation of France

★ French and U.S. troops entered Paris on August 25, 1944, and were met with a huge, emotional welcome, culminating in a grand parade down the Champs-Elysees.

Death of Franklin D. Roosevelt and the Swearing-In of Harry S. Truman

★ On April 12, 1945, Franklin Delano Roosevelt died of a cerebral hemorrhage on the 83rd day of his fourth term as President. He was 63.

★ Harry S. Truman was sworn in as the 33rd President of the United States on April 12, 1945.

Nazi Defeat

★ After a last-ditch stand by the Nazis in Berlin, the Germans ultimately gave in to the Allied forces. Mussolini was captured and hung. Adolf Hitler and his mistress, Eva Braun, committed suicide on May 1, 1945, in their underground bunker, leaving orders behind that they were to be cremated so that no trace of their bodies would be found.

★ On May 7, Germany surrendered unconditionally to the Allies after almost six years of war.

★ President Truman proclaimed May 8 V-E Day to honor the victory in Europe; it was, coincidentally, his own birthday.

The Final Phase

★ American scientists successfully detonated an atomic bomb in Alamogordo, New Mexico, on July 16, 1945.

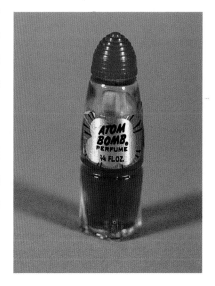

[BELOW] *Atom Bomb Perfume,* Andrew Jergens Co., Cincinnati, Ohio. ¼ fluid ounce in glass bottle shaped like a bomb with red Bakelite top.

★ On August 6, 1945, the first atomic bomb fell on the city of Hiroshima, headquarters of the Japanese regional army and a manufacturing and distribution center for military equipment. Almost five square miles of the city were destroyed in the blast, immediately killing 70,000 people; an undetermined number died afterwards from the effects of radiation.

★ On August 9, 1945, a second atomic bomb was dropped on the large steel manufacturing city of Nagasaki, which was also a shipbuilding center. The unearthly blast destroyed 1.8 square miles of the city, killing 36,000 people; the injured and missing numbered over 40,000.

★ Japan surrendered to the Allies on August 14, 1945, or V-J Day.

★ On September 2, 1945, aboard the battleship U.S.S. *Missouri* in Tokyo Bay, in the presence of Emperor Hirohito, a Japanese representative signed unconditional surrender agreements with Fleet Admiral Chester W. Nimitz and General Douglas MacArthur. The war was officially over.

★ ★ ★

John Gilman

𝒯HE WORLD WAR II HOME front for the Gilman family was Waikiki Beach in Honolulu, Hawaii. My mother and father had come to the Islands in 1938 from Shanghai; my brother Peter was born there in 1940. I was born October 3, 1941—two months and four days prior to the fateful day of December 7. After the attack my mother started calling me the "Pearl Harbor Baby." My family remained in Hawaii, an odd sort of "paradise" in those years, for the duration.

My father, LaSelle Gilman (everybody called him "Gil," LaSelle being too formal a name for a news-paperman), met my mother Heléne in 1936 at the Black Cat Cafe, a renowned Bohemian hangout in the North Beach section of San Francisco. Later, during the war years, it was considered so notorious that it was declared off-limits to service personnel. Two weeks later they married and set off, literally, on a "Slow Boat to China." Gil was an adventurer and already an "old China hand"; this trip he filled the post of news editor of the China Press and city editor of the Shanghai *Evening Post* and *Mercury*. This double-duty assignment was coupled with his work as Peiping correspondent for INS, the International News Service whose members called it "I Never Sleep" or "I'm Never Sober"; he was also covering the major phases of the Sino-Japanese fighting from Mongolia to Southeast Asia for a large Canadian newspaper syndicate.

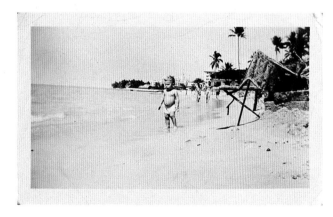

[ABOVE TOP]
"Remember Pearl Harbor,"
red, white, and blue
plastic pin.

[ABOVE]
Pearl Harbor Baby
John Gilman on Waikiki
Beach.

The metropolis of Shanghai on China's central coast beside the mighty Whangpoo River was the fifth largest city in the world with a population of over four million people and the western world's mightiest stronghold in the Far East. The Gilman newlyweds lived in elegant old world Oriental luxury, Chinese Art Deco style, in the International Settlement. By 1937, the decade-long Japanese war of aggression against the Chinese had accelerated; Manchuria and practically all of Northern China was under Japanese military control. Peiping surrendered in the spring. Hundreds of thousands of refugees streamed into the neutral and cramped territory of Shanghai seeking sanctuary. When a bomb fell through the roof of the elegant French Club in the Settlement during a VIP party, Gil figured it was time to leave; The final "rape of China"—as he called it—had begun. Gil and Heléne fled to Hawaii.

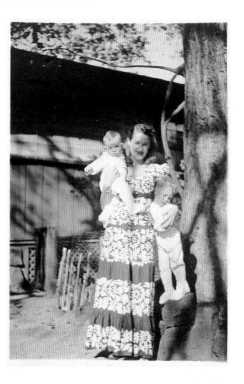

[ABOVE] *Heléne Gilman* with sons John (being held) and Peter, standing.

They set up house in a sprawling Hawaiian-style residence in the tropical Waikiki district of Honolulu, a city within a city along the famed crescent-shaped, palm-fringed sandy Pacific Ocean shoreline. Gil published a successful novel, *Shanghai Deadline,* which was made into a movie called *International Settlement* with Dolores del Rio, George Sanders, and Key Luke, and wrote a features column for the *Honolulu Advertiser.*

He often greeted celebrities at the Aloha Tower on the harbor, checked out who was on the *China Clipper* and had glamorous cocktails with Heléne at the "Pink Palace of the Pacific," the Royal Hawaiian, the old Moana, or the Halekulani Hotels. Years later when my mother was listening to her favorite weekly radio show *Hawaii Calls* she would talk about the Honolulu sunsets and the luminescent moon over Waikiki and Diamond Head. She told me that after I was born (on the day the *Maltese Falcon* with Humphrey Bogart opened on the mainland) she would take my brother and me to Kapiolani Park to swim in the lagoons. On weekends we went to the Kapahula Groin to catch the breakers, though by December 7, 1941, I was only a belly surfer. After "Pearl Harbor" the beaches were ringed with barbed wire.

Civilians and all ranks of the military were confused by the sudden Japanese air attack at Pearl Harbor. Many people thought initially that it was a drill or practice alert (a common occurrence on the islands), or one of the many tactical war games played almost weekly at one of the military bases and air fields on Oahu. Gil told me later, when I was grown up, that Honolulu, like the rest of America, was in a very relaxed, "Sleepy Serenade" mood. Shore leaves had been granted for large numbers of sailors and marines

on Saturday, December 6. The downtown honky tonk district of Honolulu was filled with carousers, many of whom visited one of the twenty-five "hotels" in the red light district. Sailors and other servicemen visited tattoo parlors, decorating themselves with hula girls, battleships, American flags and Oriental dragons painfully applied by Japanese tattooists in the Makiki district. Gil talked ominously about a 2-column "filler" article that had been printed in the *Advertiser* a week before the attack describing the mysterious "disappearance" of a major Japanese fleet in the North Pacific. Nobody paid any attention to it. He joked that the Rising Sun of the Japanese Empire was dogging his trail from Shanghai to Honolulu.

It was a perfect dawn over Oahu on Sunday, December 7, 1941. Lt. General Walter C. Short, commanding general of the Army, and Admiral Husband E. Kimmel, the commander in chief of the United States Pacific Fleet, were playing golf. Military or civilian, no one was prepared for the suddenness of the attack and most people couldn't believe that it was actually happening. My mother told me that the noise from the explosions set me to screaming and kicking in my crib, finally knocking it over onto the floor of the *lanai* where I had been sleeping. Mother rushed out, picked me up, unhurt, and retreated back inside to the safety of the house, her flowing Hawaiian *holoku* shielding me from the flying glass. My father was frantically on the phone with his editor at the *Honolulu Advertiser* and rushed out immediately to cover what was later to be called "the story of the century."

His first-hand eyewitness adventures that day appeared in a front-page article in the first newspaper published on the Islands after the attack, an eight-page double "EXTRA" edition of the *Honolulu Advertiser* combined with the *Star-Bulletin,* dated

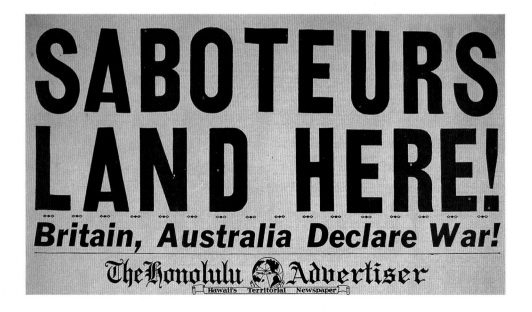

December 8, 1941. Gil said the *Advertiser*'s printing press had mysteriously broken down on Saturday. Under a banner headline reading "SABOTEURS LAND HERE," the lead article by Harry Stroup was headlined:

ADVERTISER MEN WATCH GRIM SHOW.

This is a factual account of what I saw on a trip between the *Advertiser* building and Pearl Harbor, accompanied by LaSelle Gilman, another reporter. It is uncolored and unvarnished. Shortly before 9 A.M., while aircraft shells were bursting everywhere in the blue above Pearl Harbor, we drove around by way of Vineyard Street to avoid the rush of Army and Navy personnel and defense workers who were dashing back to their posts. The streets were lined from one end of the city to the other with men, women and children, some still in their pajamas and nightshirts. All were looking westward, most of them with a somewhat perplexed expression on their faces. We expected to be stopped long before we got to Pearl Harbor, and we kept our police and military passes handy to exhibit as the need might arise. But we were not stopped. Police officers and special officers manned every intersection and road to Pearl and the Army posts beyond were kept open. Speed limits were ignored as thousands of men hurried to return to their posts. Thousands of cars sped toward Pearl Harbor. Traffic toward town was lighter but still heavy.

"You'd think the road would be closed," I said to Gilman.

"Got to get these men back to their jobs and there's no time to fool around," Gil said.

"There's a plane there low down, just over our heads," I said, shouting for no reason at all.

"You keep your eyes on the road, I'll watch the planes," Gil said.

From Vineyard Street we drove into Houghtailing Road and thence *makai* on King and through Fort Shafter to the old Puulos Road, thence onto the Pearl Harbor Road along to the base.

We saw a military ambulance driving toward town on Vineyard Street, later after we went through Fort Shafter we passed four other military ambulances driving toward the city.

"Looks as if there have been a few casualties," Gilman said. All through Fort Shafter there was great activity and we could hear the sharp *rat-tat-tat-tat* of machine guns and the heavier firing of anti-aircraft batteries. Hundreds of men could be seen deploying and taking up positions in Moanalua Park and in the Kiawe Forest surrounding the military reservation.

The anti-aircraft fire became more intense as we neared Pearl Harbor and now and then we could see a low-flying plane. We saw a number of planes zooming downward directly over Pearl Harbor, and presumed that they were dive bombers. What struck us strange was that no effort was being made, even within the immediate area of Pearl Harbor and Hickam Field, to seek shelter. We did see two women attempting to hide under the rear cover of a Ford coupe, and as we sped past they peeked out and shook their hands at us, just as a wrestler grasps both hands in answering the acclaim of the crowd.

For the most part people, women and children included, stood in the open and watched the "show."

While speeding along the Pearl Harbor road just this side of the gate to John Rodgers Airport we got our first taste of real excitement.

A plane, we don't know whose, zoomed close overhead from the rear and we could hear the now familiar *rat-tat-tat-tat.* Then suddenly, the tops of several small Banyan trees on the *mauka* side of the road started falling off.

Then we noticed red sparks bouncing up from the pavement in front of us and a car blew a tire and went zooming into the ditch on the *makai* side of the highway. As we drove by we looked to see how the driver was making out. He got out and waved us on and we kept going.

Driving past Hickam Field we noticed what appeared to be a cloud of dust, and we could see a large number of planes sitting on the edge of the field. Some of them seemed to be damaged.

Within a few minutes we were at the Navy yard gate and on our way.

An hour later we started back to Honolulu, after learning that it was impossible to telephone the paper. All lines were being reserved for the Navy, an officer bluntly informed us. We understood.

At the Hickam Field housing project we stopped to give a ride to a group of women and children standing alongside the road.

"They ain't going in," a guard shouted, and we kept going.

Press censorship prohibited the writers from describing what they saw inside the military base. My father returned that afternoon just before dusk and we all huddled together during the long night, the stars twinkling brightly above in a cloudless sky, the island below in a complete blackout. Life changed drastically for everyone in Hawaii after the attack. Martial law was imposed on the first day and lasted until October, 1944. With the very real fear of a Japanese invasion, strict night curfews were imposed. Essentials

disappeared overnight; severe food and housing shortages developed immediately. Travel priority was given to military personnel. The blackouts every night were real—no half measures—no street lights, no electric signs and no lights in homes visible from outside. Windows were covered with tar paper and black paint and had to be kept closed at night—a difficult situation in an age and place where air-conditioners were unknown. Almost everybody ate before sundown and went to bed early, unless they were on duty. Fines and suspended jail sentences were handed out for a show of faint light from the glow of a radio dial or a lighted cigarette.

After the attack, Gil started writing a column in the *Advertiser* called "Hawaii War Diary." The May 2, 1942 column noted the rigidly enforced blackouts:

> "which brings us to another gripe—those tickets for 'flash' violations . . . the cops camp on the curb waiting for some absent-minded victim to show a momentary light—then nail him . . . that isn't intelligent policing—it's bullying the citizenry."

Blackout restrictions were not lifted until July, 1944.

Another column commented on the unusual mandatory decree that all children over the age of eight must work one day in the fields. Fortunately my brother and I were too young to be affected by this edict.

> "For molesting pedestrians and making nuisances of themselves," my father wrote, "the shoe-shine boys are probably the worst. Newspaper vendors, however, run them a close second. Along Hotel Street . . . shoe-shine boys—apparent ages, 6 to 12—grasp . . . at the hands or clothing of passersby, particularly servicemen . . . and shout 'Shine Mac,' and 'Hi, Pal.' . . ."

In December, 1942, on the first anniversary of Pearl Harbor, Gil wrote an article called "The Year in Retrospect" for the *Paradise of the Pacific* magazine. "The population of the Territory has expanded amazingly . . . any casual observer on the streets of Honolulu . . . could see that uncounted thousands of soldiers and sailors have arrived. . . ." In the same article Gil predicted accurately "No one . . . expects to see the Territory ever to return exactly to the conditions that prevailed here before the war." Where there had been a boom, now there was a bust. Tourism disappeared. The Royal Hawaiian Hotel became the "R & R Annex"—rest and relaxation—for Pearl Harbor Submarine Base personnel, sailors, and aircraft pilots who paid only twenty-five cents a night for what had been forty- and fifty-dollar suites.

[BELOW]
"Christmas in Hawaii" dinner menu and program, 64th Coast Artillery, Fort Schafter, Territory of Hawaii, December 25, 1941.

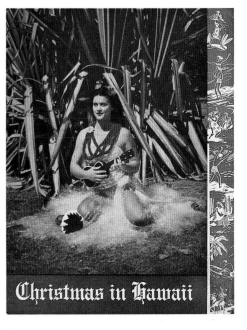

My parents were hosts to many VIPs and U.S.O. celebrities passing through the islands on their way to the South Pacific to entertain the troops. Our wide-open home was visited once by Bob Hope—according to my mother I sat on his lap—and I was coddled by glamorous Dorothy Lamour, comedian Jerry Colonna, and singer Frances Langford (whom, I was told, was quite taken with the "Pearl Harbor Baby"). One of our most illustrious visitors was none other than Madame Chiang Kai Shek, the Nationalist Chinese leader's wife, and one of the famous Soong sisters. Invoking an ancient Chinese tradition, she made a gift of her antique Oriental lapis lazuli ring to my mother who had admired it. For many of these gatherings my parents, against all regulations, concocted a home-made tropical champagne brewed in a storage cellar from fermented pineapple. My mother performed the *hula,* which she also did professionally on occasion with the "Hula Troupes" who entertained servicemen at island camps. During the war, my father was recruited by Naval Intelligence as a special war correspondent and was transported by submarine throughout the South China Seas.

Shattered by the stress and pressure of wartime in the islands my parents divorced, re-married, and divorced a second time. After the war, my mother, my brother, and I returned to the U.S. mainland and lived on Telegraph Hill in San Francisco. Gil wrote stories for the *Saturday Evening Post* and *Colliers Magazine* and authored several successful Far Eastern adventure novels, which included, in addition to *Shanghai Deadline, The Dragon's Mouth, The Golden Horde, The Red Gate,* and *Sow the Wind.*

My own interest in collecting Hawaiian and World War II memorabilia has grown since I discovered a few years ago an original copy of the December 8th, 1941, "EXTRA" edition of the *Honolulu Advertiser* featuring my father's harrowing adventures on Pearl Harbor Day. My collection now includes Hawaiian shirts, "Remember Pearl Harbor" buttons, pins, satin pillowcases with images of Diamond Head and Waikiki, Hula-girl lamps, Matson line menus, and other printed period ephemera. I was amazed recently when I found a photo magazine called *Looking at Honolulu* published in Honolulu in 1943 which featured a prominent picture of my mother, my brother, and myself accompanied by my mother's best friend Barbara Dole, the pineapple heiress, and her two daughters. The women were wearing low-cut halters and tropical patterned sun skirts. The caption read: "Residents of Waikiki revert to the comfort of the early islanders in the scantiness of their everyday attire." These mementos and gathered impressions allow me to visualize my childhood in Hawaii, though I have no real, concrete memories. However, the special media focus on Pearl Harbor Day throughout the years and spotlights on anniversaries, particularly the fiftieth, combined with my parents' stories, have given me the curious feeling of almost remembering.

Home Front—Two Personal Accounts

★ ★ ★

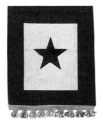

Robert Heide

*F*OR A BOY LIVING through the unsteady times of World War II in a small town in the United States, I remember the intense family togetherness mixed with feelings of sweet sadness, a hopeful yearning for a peaceful future, and the directive that permeated everything: WE HAD TO WIN THE WAR! As a youngster, I sought to emulate the fantasy comic book heroes I idolized like Captain Marvel, Superman, or Robin (Batman's side-kick), who were on the side of right and might and who had to destroy the putrid and evil common enemy. Idealistic to the extreme, that was the way we were; and as All-American kids we saw ourselves as good guys who were united against the bad and who fought for

victory at all cost. To a child like myself much of the home front idea of combat seemed to be more akin to play. Since no real bombs ever fell on my hometown, it all appeared to my vivid imagination to be happening around me in some make-believe land of war that was offered up by the movies, the radio, the comics, or as some item you could buy at the Woolworth's toy counter for a dime, such as a wartime puzzle, a battlefield game, a toy gun or tank, a *Terry and the Pirates* (at war) Big Little Book or a complete boy's military outfit including a helmet, a G.I.-type "dog tag," a "sparkle-fire" friction machine-gun, or the like.

Irvington, New Jersey, where I grew up was typical of most small middle-class towns across America during the World War II years. A cobblestoned Springfield Avenue was the main street that went directly through the center of town. Steel trolley tracks were

[ABOVE] *Single-star window banner.*

[BELOW] *Olga,* Robert Heide's mother (left) with Aunt Alma in front of 34 Franklin Terrace, Irvington, New Jersey, April, 1942.

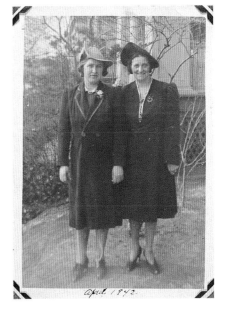

April 1942.

imbedded into the street but the old cars were replaced in the 1940s by streamlined electrical Public Service buses that took passengers, shoppers, and workers from the suburbs into the busy commercial downtown area of Newark, to Penn Station, and Ferry Street. In those days Newark had splendid department stores like L. Bamberger's, Kresge's and Hahne's as well as huge Woolworth's and McCrory's dimestores. Irvington had its own town shopping-center with two five-and-ten-cent stores; two movie theaters, called the Liberty and the Castle club; and many other attractions.

I lived up the hill from the town center and just off Springfield Avenue, in a big, barn-sized, wood-framed home at 34 Franklin Terrace along with my parents, and my sister Evelyn and brother Walter, who were both a generation older than myself. Jiggs, a bright fox-terrier, named after the high-hat comic strip character popular then was regarded by our household almost as another family member. Most of the small shops on Springfield Avenue in our own top-of-the-hill neighborhood area were of the family-owned, Mom-and-Pop variety: the Franklin Bake Shop, a corner butcher that specialized in homemade bologna, a dry-goods store, and Klein's Candy Store where I could purchase penny candy, malted milkballs, gumdrops, ten-cent comic books, and—for my sister— the latest Hollywood fan magazines.

A few blocks away was yet another Irvington movie house, the Warner Brothers Sanford Theater. During the war years I enjoyed spending entire weekends there looking at double features: Bugs Bunny-Elmer Fudd, Porky Pig, and other cartoons; war newsreels; and endless "Previews of Coming Attractions." After the fifteen cent picture-show, a group of happy kids would cross the street and head immediately for Mehrkin's Ice-Cream Parlor with its shiny-surfaced dark wood-paneled walls accented with inlaid Deco mirrors and bright stained-glass wall sconces. There you could indulge in an ice-cream soda (fifteen cents) or a banana split (thirty-five cents) with three scoops of ice-cream and homemade whipped cream. The smooth voice of my favorite bandleader-singer, Vaughn Monroe, issued forth from the colorful bubbling Wurlitzer jukebox for just a nickel—or you could enjoy six different song platters for a quarter.

My favorite jaunts would be a visit to one of Irvington's or downtown Newark's glittering dime-stores where I would beg my mother to buy a Better Little Book, a comic-character paint book, or a metal tank, lead soldier, or a truck. At my father's urging and much to my chagrin some of my metal toy collection, airplanes, toy cars and pop-G-Men guns wound up in a school scrap drive for the war effort. Shopping tours were always made with my mother, who usually agreed to my need for some kind of new distraction. I saw these things as my escape to other worlds filled with imaginary adventures and excitement.

A great number of German immigrants including my father Ludwig and mother Olga had settled in towns like Irvington or the bordering town of Union in the 'teens and twenties. Grandparents, aunts, uncles, cousins, and family friends often then referred to Europe as "the old country" and looked hopefully to America as a land of promise and opportunity. As U.S. citizens their loyalties had been given over to "the new country." To our extended German-American family Adolf Hitler was seen as a monster-menace who was causing havoc in Europe, a terrible threat to the free world we now inhabited. Sons and sometimes daughters enlisted or were being drafted into the service to fight a "home" country in the grip of a Nazi party. My brother Walter, who turned eighteen during the war, joined the Army Air Force to become a tail-gunner on a bomber that flew many dangerous missions over Italy and Germany. Cousin Sonny became an Army Paratrooper and later joined the Navy full time and another cousin, Teddy, went into the infantry.

For the war's duration we kept a small banner in our front window for my brother. A blue star against a white satin background framed in a red-felt border showed the world and passersby that our house like many houses had a son—or daughter for that matter—on active duty in the service. Some banners had more than one blue star on a field of white; and if a serviceman lost his life in battle, a banner with a gold star was hung in the window, a symbol of the utmost sacrifice.

During the war my father, who had previously been a tool- and dye-maker, contracted to do defense work for the Singer Company (manufacturers of sewing machines) in Elizabeth, New Jersey. My sister Evelyn worked part-time after high school at Uncle Fred's new stainless-steel diner situated next to a gas station in the Vailsburg section of Newark. Following her job as a part-time diner-girl-waitress and after graduating from Frank Morell High School, Evelyn decided to accept an office position at the Prudential Insurance Company in downtown Newark. There she purchased savings bonds and a hopechest, and began making her own suits and dresses on her Singer sewing machine from sendaway fashion magazine patterns.

The home-front housewife activities accomplished by my mother, other than grocery shopping, cooking, washing, ironing, scrubbing floors, and cleaning windows, were knitting khaki-colored scarves, sweaters, and socks for the boys in camp or on over-

[BELOW] *Sister Evelyn and Uncle Fred* (in white) and other staff members at Fred's Diner, Vailsburg section of Newark, New Jersey.

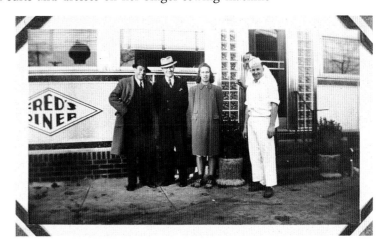

seas duty. Once a week a group of women, including my aunts Martha, Alma, and Great Aunt Gussie, would get together along with my mother at one another's homes to knit, gossip, play card games, and exchange wartime home recipes over perked Bokar coffee and homemade baked goods.

Spring, summer, and fall my father's spare time went into tending a Victory garden in our backyard. Each season would yield red ripe and yellow tomatoes, carrots, beets, lettuce, and other vegetables in great abundance. Some were given to our neighbors; but much of it would be cooked up by my mother to be preserved in glass-sealed Mason jars which were stored in the cellar pantry. My mother dressed for this chore in a flower print housedress, a plaid, floral, or checkered patterned apron, and always wore a hairnet to protect her tight permanent-wave hairdo. She regarded her Victory canning as serious work.

At that time few homes had freezing compartments although a company called Bird's-Eye began packaging frozen vegetables that easily fit into the freezing compartment of a Frigidaire, and could be purchased at the A&P. My mother's kitchen pantry was well stocked with canned goods and often at lunch she would serve Campbell's soup with a bologna, egg-salad, or tuna fish sandwich. Like artist Andy Warhol, a wartime baby who later transformed the label into a pop-art icon, I practically grew up on Campbell's "condensed" soups. Sometimes an entire meal would be served up out of a can. Canned Spam or a meat product called Treet could be pan-fried in Spry or Crisco or baked, just like a real ham, in the oven with slices of Dole canned Hawaiian pineapple. These cheap

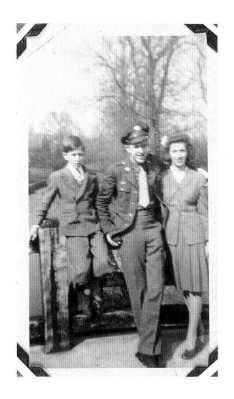

wartime meat products would then be sliced and put on a plate next to cost-saving, out-of-the-can Del Monte peas, Franco-American spaghetti, or Heinz baked beans.

Wartime regulation ration stamps seemed to confuse my mother and the grocer as well; but everyone made an effort to do their very best for the sake of Victory. Waste fat or bacon or chicken was saved and taken to the butcher, supposedly to be used in the making of bombs. (To this day, I'm not sure how.) Because meat was scarce we seldom had steaks, which were particularly hard to come by. For the most part, it was meatloaf, chicken fricasee, beef stew (with potatoes and carrots), and an occasional pot-roast, roast pork, or a roast chicken on Sundays. If fresh vegetables were used, like string beans or broccoli, they were always overcooked and unappetizing. Meat was stretched out; but there were always massive bowls of mashed potatoes to fill us up.

When my father came home from work at 5:30 P.M., it was suppertime. Afterwards the family would gather together in the living room which was dimly lit with 25-watt light bulbs to save on energy. The focal point was the R.-C.A. Victor stand-up console radio. The walls were covered with a dark forest green wallpaper with a maroon-and-gray floral pattern overlay. A three-cushion sofa and two chairs were overstuffed in matching maroon and green velour. In spring and summer they were covered with home-made chintz flower-print slipcovers. The Sears and Roebuck rose-color rug also had a busy zig-zag floral pattern. The other furniture pieces included a cobalt-blue mirrored coffee table and an upright piano holding stacks of Depression-era sheet music and the latest World War II song hits. A framed print of two cranes in a Florida swamp setting hung over the fireplace and hand-embroidered pictures of houses by the side of the road or American flags also hung on the walls. The sun porch was filled with Noritake knick-knacks, a set of maple furniture, and potted plants.

With my brother overseas, Mom, Pop, Evelyn, and I, along with Jiggs, listened enraptured to the radio for the latest war news reports, or perhaps to hear a message from President Roosevelt. After "news" my father would switch the dial to "The Answer Man," a program of listener questions and answers from Albert Mitchell who was "The Answer Man." My father's favorite show was "Amos 'n Andy." Mother listened regularly to "One Man's Family," a home drama about the Barbour family who cherished American family values and patriotism above all else. Sometimes during a sermonizing speech by Henry or Fanny Barbour to their "bewildering" offspring, my mother's eyes would glisten over as she knitted or crocheted furiously. I preferred Baby Snooks played by Fanny Brice or Edgar Bergen and Charlie McCarthy.

As the war progressed my sister Evelyn seemed to experience what my father called "dark moods," retreating into her bedroom to listen to the Glenn Miller Chesterfield broadcasts or "The Make Believe Ballroom" on her own small, white "baby" Philco radio that emanated a mysterious red glow when it was turned on. Soon I joined in listening to her favorite music shows sitting in a chair near her bed. I would read a Captain Marvel comic or one of her Modern Screen movie magazines while snacking on Cheez-its, pretzels, and drinking Hoffman's ginger ale, all the time wondering when our brother Walter would return from the war or when the war would be over. Sometimes Evelyn would take me along with some of her bobbysox girlfriends to the Adam's or Proctor's Theater in downtown Newark to see one of the big bands like Harry James or Jimmy Dorsey. A fan of these swing bands, she collected their "platters," usually buying two or three 78 rpm records each payday. She particularly seemed to enjoy the "new" vocalists Dick Haymes and Jersey-born Frank Sinatra, who originally sang with a group

called the Hoboken Four and later with the Tommy Dorsey Orchestra.

Before going out on a Saturday night to a local U.S.O. dance, Evelyn would apply the newest "Hollywood" cosmetics from Woolworth's or McCrory's dimestores or from the fancier cosmetic counters of L. Bamberger's department store. I would watch in fascination as she made an attempt to mimic the sultry allure of Dorothy Lamour or Ann Sheridan. The long process in front of her large, round vanity mirror would begin with an orange-tan pancake base to be smoothed onto the skin with a small sponge. Following this, a bright poppy-red Tangee rouge would be patted onto the cheeks to emulate the all-American healthy glow of Betty-the-Coke-Girl. After powdering and toning, eyebrows would be penciled in and Mabelline black mascara brushed onto the lashes to make them appear longer and thicker. A final touch would include blue, green, or lavender eyeshadow and finally the carefully applied dark cranberry or "Victory" red lipstick occasionally drawn over the natural lipline for a fuller mouth.

Entertaining and being hospitable to men in the service who were on leave or about to be shipped out overseas was considered almost a patriotic duty; and when my sister Evelyn and cousin Doris went out to one of these servicemen's dances it all seemed to be in good fun. True, there was the hope chest filled with blankets, curtains, and even a compartment for war bonds; and there was behind it the dream of a married life off in the future. There would be tears in the eyes of these two girls as they talked quietly of a young man they had met and might never see again. Feelings of longing and loneliness were always just beneath the sparkling surface of upswept hairdos and cherry-red lips as the girls prepared to go out.

Sometimes, men in uniform, a soldier, a sailor, or a marine would come by the house to take my sister out on a date. They would take her out to the movies or to hear the Glenn Miller Orchestra or someone else at the Meadowbrook in nearby Cedar Grove. Letters from one of these servicemen would arrive and Evelyn would read and reread them over and over again. With a misty look in her eyes, she would put a 78 rpm platter on the phonograph playing some ballad with lyrics like, "I'm a Little on the Lonely Side Tonight" or "You'll Never Know Just How Much I Miss You."

My cousin Sonny, the paratrooper who told exciting stories about jumping out of airplanes despite his frequent doubt that his chute would not open, was a hero of mine and the apple of his mother's eye. Visits from Sonny, who enjoyed my own mother's home-cooked meals, were always filled with good cheer and laughter. He could hold a captive audience spellbound with his first-hand true-adventure experiences and war stories. A brash, good looking blond jokester, girls chased after him, and he was the first to tell tales about these affairs, much to the embarrassment of my mother. My father and he would

drink boiler-makers (Four-Roses whiskey with beer chasers), talking in loud voices and generally raising hell into the wee hours of the morning.

One night the family was gathered around the console radio listening to a broadcast, when I heard the sound of a jalopy pulling into the driveway. Out of the window I could see my aunt and uncle in their 1928 Ford. When I opened the door Aunt Alma was standing there clutching a yellow envelope, tears rolling down her cheeks. Uncle Louie stood behind her on the porch staring downward with a fixed gaze. Aunt Alma handed my mother the telegram which read: "We regret to inform you that. . ." It seemed that no one uttered a single word for a long period of time. Evelyn turned down the radio; and there was a choking silence. We were dumbstruck and bewildered, unable to explain why Teddy, out of so many, was one of the unlucky ones. The next time we went to visit Aunt Alma and Uncle Louie, a single gold star on a banner hung in the window. Teddy left behind his bereft parents, two sisters, Mildred and Gertrude, and a war bride with a new-born baby girl.

I remember the sense of unity the war seemed to bring to families like my own on the home front. Neighbors and teachers became Civil Defense officers, purchasing their uniforms from local dry goods or department stores. During trial air raids, which seemed all too real to me, we would sit silently on the floor as my mother and father pulled the blackout drapes across the windows. Until the sirens stopped, or an announcer on the radio station told us the air raid drill was over, we remained motionless and silent. I would sometimes imagine that a bomb was falling and would hide under my bed with Jiggs. I remember during kindergarten and grade school being led with my other classmates by my teacher to a sub-basement area during one of these trial raids. All the children were fearful that the enemy might drop a bomb on their school.

During the summers we went to the family bungalow in Seaside Heights, New Jersey. Being close to the ocean I somehow feared an enemy invasion even more. At night on the boardwalk, which was filled with rides and games of chance, huge blackout curtains would be secured so that "the enemy" could not spot vacationers having a good time. I once thought I saw a German submarine off the coast; but I was told by the adults that I had "an overactive imagination." Later I learned that U-Boat attacks by the German Navy occurred off the Jersey coast from the beginning in January of 1942, lasting for many months. The U.S. Navy finally drove the German fleet away; but dozens of ships on both sides went down, several within sight of the Jersey shore boardwalks. Recently newspapers have reported that a German submarine from World War II—sunk by a depth charge from a Civilian Patrol aircraft in July, 1942—had been found sixty-five miles east of Point Pleasant, New Jersey. A diving team discovered the U-Boat at a depth of two

hundred and thirty feet, bringing up bowls and dishes emblazoned with swastikas, Nazi eagles, and "1942." Now I think perhaps I did see something.

Another summertime escape hatch for me and my friends was Olympic Park, a grand old-style amusement park operated from 1887 to 1965. Just a few blocks from our house, it consisted of a beer garden with a bandstand. There Captain Joe Basile led a brass band featuring an ex-trapeze artist named Bubbles Ricardo. Bubbles sang songs like "When the Lights Go On Again All Over the World" or "When Johnny Comes Marching Home." During the war years, Bubbles always opened her set with a rousing patriotic rendition of "The Star-Spangled Banner" and asked everyone to join in.

During World War II, Olympic Park was covered with patriotic red-white-and-blue banners and flags. Concessionaires managed games of chance or skill and offered prizes of painted chalk or plaster statues pasted with glitter depicting soldiers, sailors, WACs, or "Victory Pups." These were often found in 1940s homes standing on top of the mantelpiece or atop the family console radio. The penny arcade offered slot-machine postcards of pin-ups, some in patriotic attire, or postcard photos of war heroes, cowboys, or movie stars. One game of skill was called "Mow the Jap Down" and the prizes from this concession might be a comic Hitler, Mussolini, or Hirohito ashtray.

[ABOVE] *"The Victory Pup"* painted plaster savings bank, an amusement park prize. (Hake's Americana, York, Pennsylvania)

Our family, along with several others in Irvington and elsewhere across the country, kept preoccupied and busy "For the Duration," always seemingly confident that America was the best place in the world in which to live. The feeling was also that America—the home of the free and land of the brave—could win any battle at hand by virtue of might and right.

In later years I began to discover some of the things I remembered from my childhood at the flea markets, garage sales, antique shops, shows, and specialty military exhibitions that I love to haunt. I particularly enjoy finding and looking through war period magazines with their wonderful ads, stories, photos, and illustrations. The sheet music, often with excellent graphics on their covers, and 78 rpm records of this time still hold a strong fascination for me. Most of my family—my mother and father, the aunts and uncles that I knew, and my sister Evelyn—are now gone. My brother, Walter, a World War II vet, lives with his family in Orangevale, California. All that remains now is the warm glow of memory. Some of this is brought back for a moment when one of these wartime "things" sets off a kind of emotional recall—as if it all happened just yesterday. A tune on the radio like Frank Sinatra singing "I'll Be Seeing You," Doris Day singing "Sentimental Journey," or Anita O'Day singing "Comin' In on a Wing and a Prayer" actually seem to turn back time— if only for a few moments.

The Bugler's Call

A GALLERY OF LEADERS

★ ★ ★

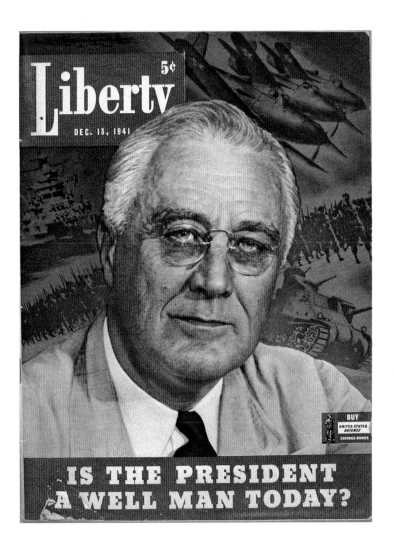

[LEFT] *F.D.R. himself* on Liberty magazine cover, December 13, 1941.

[BELOW] *Prime Minister Winston Churchill* of England as an unglazed chalk figurine by "Stadig."

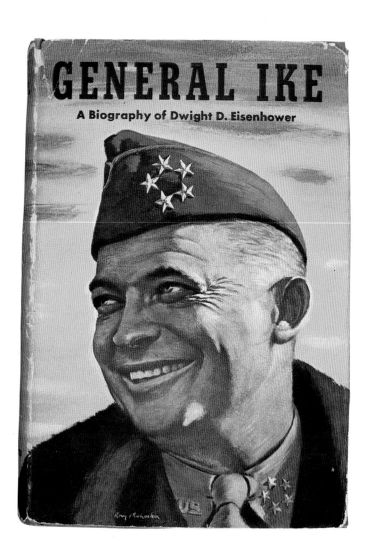

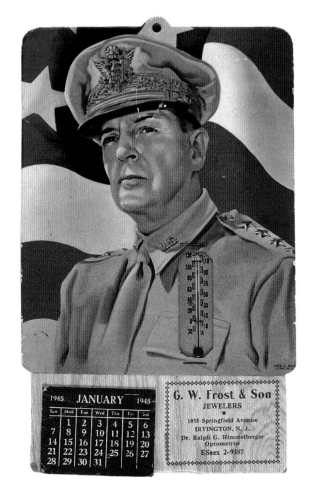

[ABOVE] *General Ike*, a biography of Dwight D. Eisenhower by Alden Hatch, Consolidated Book Publishers, Chicago, 1944.

[RIGHT] *General Douglas MacArthur* calendar with thermometer, litho on cardboard, G. W. Frost & Son, Jewelers.

The Bugler's Call

★ ★ ★

*D*URING THE 1930S WHEN a raging, storming Hitler first began to invade his neighboring territories, he was admired in his own country but feared and hated practically everywhere else. The great German Fuehrer soon began to appear in caricature in magazines, in illustration for news articles, or in comical jokes. At this time seeing a pack of hard-faced brown-shirts doing the goosestep with the precision of the Radio City Rockettes, one arm raised upward at a vertical angle, and screaming out a "Heil Hitler!" must have appeared ludicrous to many Americans. Laughing at Hitler's trademark haircut (with his bang falling over half his forehead), his square-shaped little black moustache, and his dark, brooding eyes, by turns filled with scorn, rage, or angst, became a popular sport in periodicals and cartoons of the day. Slick upscale magazines like *Vanity Fair* or *Ken,* which catered mostly to a privileged class, portrayed Hitler alternately as just a sheep in wolf's clothing or as the Big Bad Wolf (a caricature that was also used as a comic-euphemism for the Depression in the 1930s). It was no folly or accident that Charlie "The Tramp" Chaplin played Hitler in the film *The Great American Dictator* (1940). Some critics duly noticed a physical resemblance between Chaplin's bewildered tramp character and Hitler himself. Mickey Mouse, Felix the Cat, and Betty Boop's pal, Bimbo, were sharp black-and-white comic-character images, and so Hitler with his exaggerated looks could join in, though only as villain.

As America entered into World War II, Hirohito and Mussolini also joined this comical parade, although Hitler was always in the forefront. Hitler's chief henchmen Joseph Goebbels and Hermann Goering were also caricatured along with many anonymous "Jap" soldiers or fliers who always possessed squinting eyes

[LEFT] *A Nazi skunk* painted-on-reverse glass ashtray.

[CENTER] *"Rising Sun" rat* painted-on-reverse glass ashtray.

[RIGHT] *Fascist vulture Mussolini* painted-on-reverse glass ashtray. (All: courtesy Ted Hake)

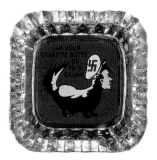
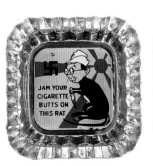
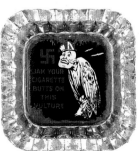

and protruding teeth. Hirohito was sometimes portrayed as a buzzing insect or a rat. Hitler was frequently turned into a skunk or a pig. A bald Mussolini with his jutting jaw and popping eyes appeared to be a fierce yet perpetually dumbstruck knucklehead.

At wartime gift shops, novelty and "trick" shops, or in amusement arcades you might take home a plaster statuette of Hitler, his posterior turned into a pin-cushion, or a Mussolini or Hirohito ashtray which you could use to extinguish the butt of a cigarette. In a symbolic way these curios in a home were prized as trophies, the joke being "The Enemy" had already been captured or contained.

War posters used in a defense plant, a school, or at a training camp often depicted Hitler, Mussolini, Hirohito, the "Japs," and the Nazis comically, heralding the "Big Three" with the slogan, "Set 'em on their Axis!" A poster of a Japanese soldier being squeezed in a vice tightened by American workers reads "Squeeze the Japanese!" Another workplace poster shows a home front "soldier" punching his time-clock, imagining he's punching Hitler. Often posters had a vicious or hateful implication. In this sense "The Enemy" was regarded in terms of demonology, as devil-worshipping anti-Christs, rapists, and murderers. American war propaganda encouraged this vision of bloodthirsty villains and torturers who had no mercy for their victims, even before the monstrous war crimes, particularly in the German death camps, proved the truism that an unchecked war can breed horror and unspeakable atrocities.

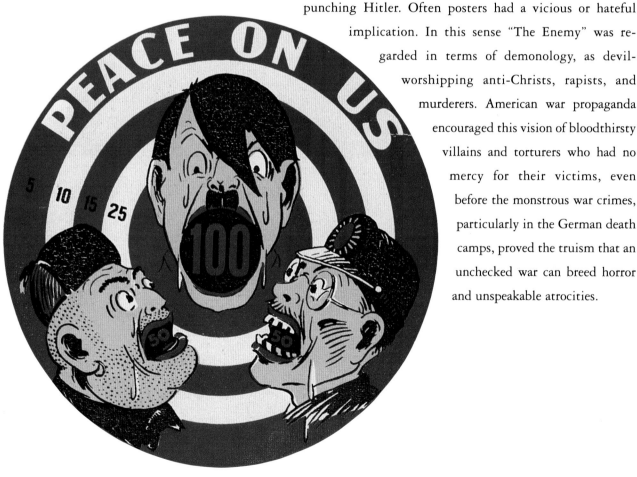

[ABOVE] *"Peace on Us"* transfer decal with Hitler in the bulls-eye, Mussolini, and Hirohito.

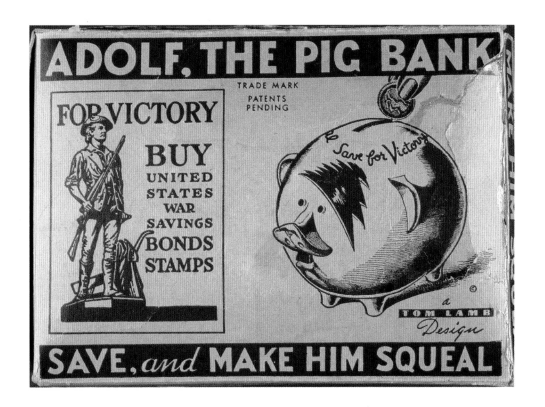

ADOLF, THE PIG BANK

TRADE MARK
PATENTS PENDING

FOR VICTORY

BUY
UNITED
STATES
WAR
SAVINGS
BONDS
STAMPS

Save for Victory

a
TOM LAMB
Design

SAVE, and MAKE HIM SQUEAL

[LEFT] *Box for Adolf the Pig Bank,* designed by Tom Lamb.

[BELOW LEFT] *Hitler as a ceramic skunk.*

[BELOW RIGHT] *"Hotzi Notzi"* Hitler pincushion on painted plaster figure—*"It is good luck to find a pin—here's an 'Axis' to stick it in."*

(Top and below, left: courtesy Ted Hake)

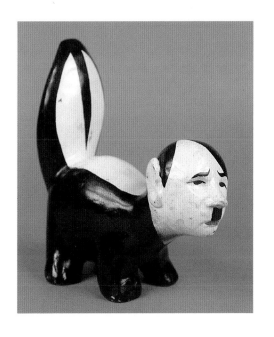

The Bugler's Call

★ ★ ★

"The enemy has struck a savage, treacherous blow.
We are at war, all of us! There is no time for disputes or delay of any kind.
We must have ships and more ships, guns and more guns,
men and more men—faster and faster. There is no time to lose.
SPEED IT UP. It is your nation!"

Frank Knox, Secretary of the Navy
(after Pearl Harbor)

*T*HE AMERICAN HOME FRONT mobilized at once for war after Pearl Harbor; the U.S. Government printing office in Washington, D.C., created almost 200,000 different posters, a great many of which contained handsome and striking images of men and women at work, servicemen in battle, or a menacing visage or caricature of the enemy. Different types of World War II posters were developed to inspire the fight to victory. To mobilize the home front war effort, renowned commercial artists like Norman Rockwell, Ben Shahn, and John Stewart Curry, along with photographers like John Albok or Morris Huberland, were put to work selling the American public on the idea of rationing, conservation, war production in industry, scrap drives, Victory gardens, and recruitment into the armed services. Travel posters emphasized the use of car pools, advising comuters to travel by train or by bus only when necessary. These artful posters that once had to tell a story using only strong graphics and a direct statement can now be viewed as great historical documents of the war and the home front, as well. Since patriotism was the order of the day, the bold colors or the continuous use of red, white, and blue flags, banners, or "V" for Victory emblems give these posters a particular appeal.

In the August 1941 issue of *Fortune* magazine, several posters advertise America's involvement in the inevitable war that was about to happen. One poster-illustration shows an American factory worker with a Nazi swastika lurking ominously in the background. In bold letters it reads "America Open Your Eyes." Another states "Buy Bonds

Now—No Peace Without Power!" The article in *Fortune* reads in part, "As an instrument of propaganda and morale, the poster is cheap, efficient, and pliant."

A good poster always put forth a very direct message such as "Don't Tell Secrets" or "The Enemy is Listening." This type of poster would often depict a dead soldier lying on a beach or in a bombed-out shelter, making the fearful point that somebody talked. War posters would be placed strategically in public buildings like post offices, in factories, in schools, in work places, and in servicemen's clubs. Some could be seen in the window of a local A&P foodstore stating messages like:

> "Raise and Share Food"
>
> "Walk Home"
>
> "Carry Your Own Packages Home"
>
> "Conserve Everything You Have"
>
> "Save 10% of Your Income for War Bonds"
>
> "Make Yours a Victory Home!"
>
> "Buy War Bonds!"

Smaller posters were printed for display in the window of private homes or apartment buildings. These might read, "This is a 'V' Home" or "We Are Proud to Have a Son Serving in the Army!" There were a variety of sizes, including the small window or smaller grocery stand-up sizes, larger formats ranging from the one-sheet (27" x 41") to the three sheet (41" x 81") or six-sheet (81" x 81") for use as small billboards to the 24-sheet giant billboard size used along the road and on top of the taller buildings of a town.

On January 16, 1942, the War Production Board was established by an executive order. Headed by Donald M. Nelson, the WPB was in charge of the entire war production program. At the beginning of the war work was readily available in industry but skilled workers were in short supply. War posters were created to persuade Americans to join the working ranks. Factory agents were sent door to door to recruit workers into the war production effort. With thirteen million men in the armed services, the defense-plant workers came to be regarded as the soldiers of the home front, their roles as imperative to victory as those who served in the military. Roosevelt's "Back the Attack" strategy, a slogan seen on a great number of posters, helped turn the tide that won the war.

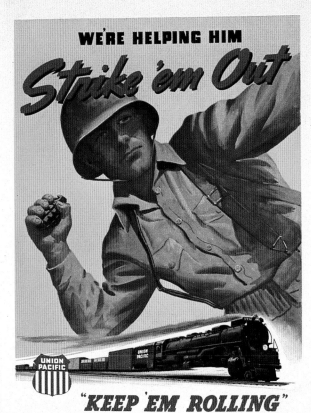

[ABOVE] *"Strike 'Em Out, Keep 'Em Rolling—We're Helping Him,"* Union Pacific Railroad.

[OVERLEAF] *"Don't Let Anything Happen to Them!—Give 'Em More!"* Warner and Swaseys, Oldsmobile Division of General Motors, Lansing, Michigan, 1942. (Both: Meehan Military Posters)

DON'T LET ANYTHING HAPPEN TO THEM!

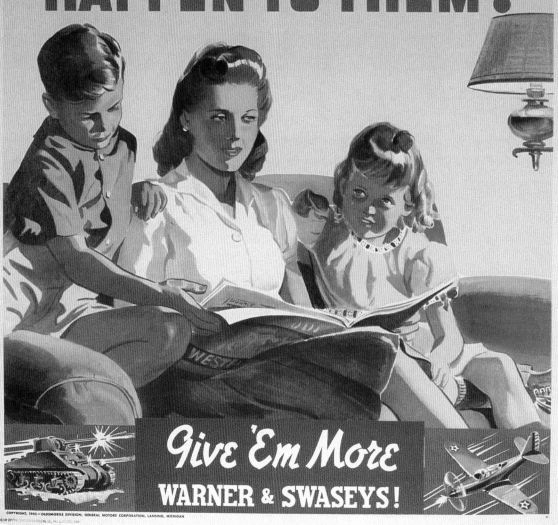

Give 'Em More
WARNER & SWASEYS!

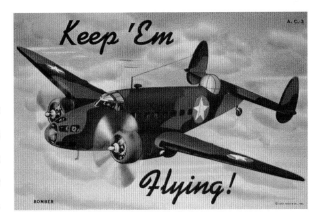

[ABOVE] *"Keep 'Em Flying"
Bomber,* U.S. Air Corps
Series postcard marked
"Genuine Curt Teich—
Chicago C.T. Art-
Colortone."

*V*ACUUM-CLEANER PLANTS TURNED to produce machine guns while the automotive industry made warplanes and tanks. *Life* magazine of February 16, 1942, sported an article with the headline, "U.S. Auto Plants are Cleared for War." The last gray Pontiac with "blackout" trim substituted for chrome rolled off the assembly line that month in Pontiac, Michigan. Ford, Plymouth, Studebaker, and Packard, as well as the other automobile manufacturers, had already ended civilian auto production by then. The immense Willow Run Chrysler factory in Detroit was referred to as "a bombers' hive-tank-arsenal" by the new defense plant civilian homefront army that enlarged the plant further after taking it over for war production. Submarines were built in the midwest and launched down the Mississippi. Shipyards worked twenty-four hours a day to produce mighty battleships, aircraft carriers, cruisers, destroyers, minecrafts, patrol and torpedo boats, supply ships, tenders, and oilers. By 1944, 96,000 aircraft alone were produced in airplane factories for the wartime effort, including fighters, scout-bombers, torpedo bombers, patrol-bombers, amphibians, long-range Navy "Liberator" bombers, transport-and trainer-type aircraft, and gliders. There were also over 200 lighter-than-air, non-rigid airships, barrage balloons, and training blimps. Between July 1940 and V-J Day in 1945 American industry produced: 639,245 Jeeps, 300,000 planes, 100,000 tanks and armored cars, 2⅓ million military trucks, 71,062 naval ships, 5,400 Merchant Marine ships, 64,000 Land Crafters, 15 million rifles, machine guns, and pistols, and 41½ million rounds of ammunition.

★ ★ ★

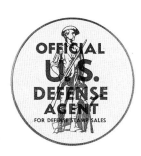

[ABOVE] *Official badge of U.S. Defense Agent* for Defense Stamp sales.

[BELOW] *10¢ "Minuteman"* United States War Savings Stamps.

DEFENSE SAVINGS BONDS WERE developed as part of a plan to help improve the American economy by then Secretary of the Treasury, Henry Morgenthau. His brainchild was embraced by Congress which authorized the plan in mid-1940. Morgenthau and President Roosevelt both agreed that by making the purchase of a bond a voluntary gesture, every American citizen could feel they were making a personal investment in the country by buying one. "Defense Bonds," meant to protect America from its enemies, were referred to as "War Bonds" after Pearl Harbor. The very first War Bond was sold to President Roosevelt on May 1, 1942, for $375; it would be worth $500 in ten years. A War Bond was, in effect, a loan by a citizen to help the government finance the tremendous war effort ahead. A $25 bond sold initially for $18.75; a $100 bond cost $75; and a $1,000 bond cost $750. If bonds were not cashed in at the ten-year maturation point the interest would continue to accumulate.

Victory Loan Drives and War Bond Rallies were held everywhere. Bonds were

sold from booths set up on street corners in downtown shopping centers of big cities and small towns. Americans could purchase the bonds at banks, post offices, department stores, movie theaters, or at the office, the factory, or the defense plant. Food stores like the Safeway, the A&P, or the Acme sold bonds throughout the war years. One food store bond-booster poster shows a pig pushing a shopping cart; above the illustration are the words, "This little pig went to market—to buy War Bonds!" The American Women's Voluntary Services helped schools, churches, and smaller groups of individuals set up War Bond Rallies or War Bond

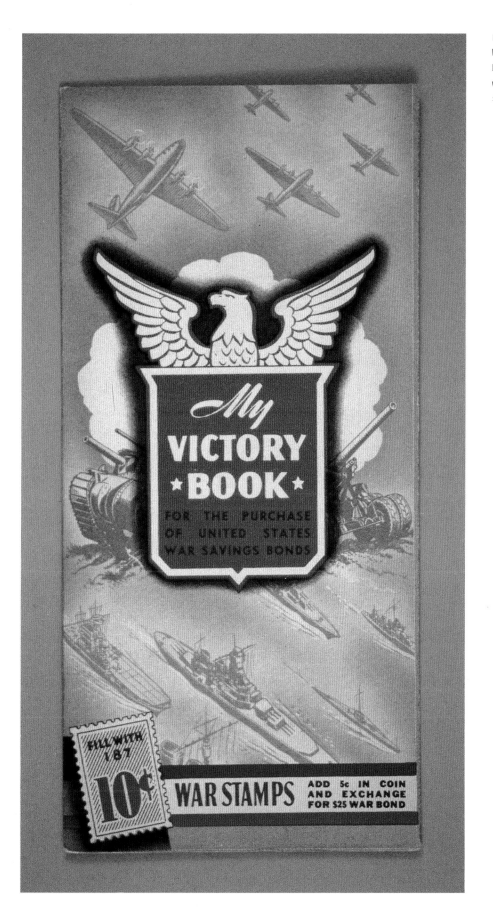

[LEFT] *"My Victory Book"* War Stamp Savings Bond booklet to be filled with 187 10¢ defense stamps.

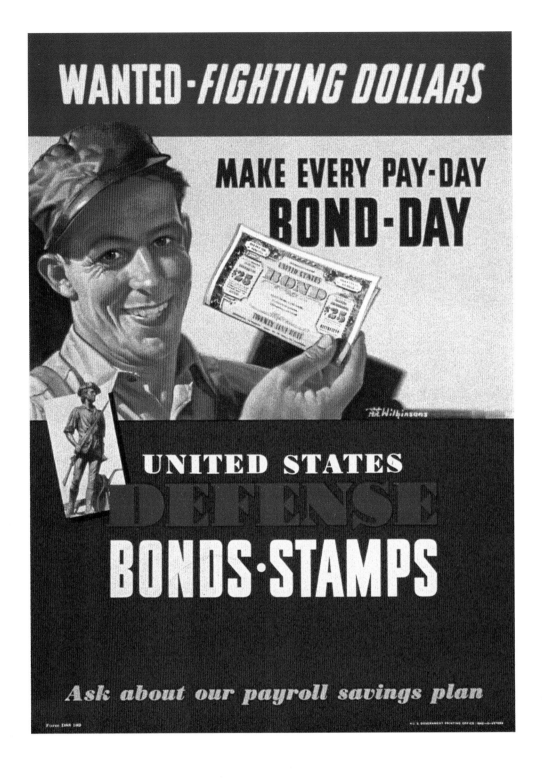

Dances. These patriotic bond-selling events would often take place during a St. Valentine's Day dance, a St. Patrick's Day ladies' bridge club meeting, or a Christmas party held at a factory or office. At school, teachers would pass out Savings Bond booklets; children would do their part for the war effort by purchasing a 10¢ or 25¢ Defense Stamp to paste in their booklets. When a book was filled with these stamps the teacher or principal would present the elated pupil with his very own Savings Bond.

The government enlisted Hollywood movie personalities to participate in the selling of War Bonds to the public. One Victory Loan show led by James "Yankee Doodle" Cagney toured sixteen cities in three weeks. Kate Smith, who sang Irving Berlin's "God Bless America" over and over again throughout the war to civilians and servicemen, raised $40 million in bonds on a single 16-hour radio show marathon. Stars like Lana Turner, Dorothy Lamour, Marlene Dietrich, Frances Langford, and Gene Tierney were happy to get out there and do their job for Uncle Sam on the home front. The Hollywood Bond Cavalcade featured a number of stars led by Greer "Mrs. Miniver" Garson. In ten major cities in just one month the Cavalcade raised over a billion dollars. A huge four-story-high cash register weighing ten tons was set up on Times Square to record the numbers in dollars and cents sold throughout the land. Impromptu shows and bond rallies took place on a raised platform in front of the great "patriotic" machine which registered donations as they came in. Carole Lombard, a tireless War Bond seller, returning from a War Bond Rally in Indianapolis, Indiana, to meet her husband Clark Gable, was tragically killed in a plane crash. Her death was viewed by her adoring public as a civilian war casualty and as a great sacrifice to the war effort.

On each Defense Savings Stamp appeared the patriotic image of a Revolutionary War Minuteman; many citizens dressed up as Minutemen and sold stamps and bonds in shopping centers. The largest Bond Rally was held at the foot of the Lincoln Memorial in Washington, D.C. Again James Cagney was at the helm accompanied by stars like Betty Grable, Veronica Lake, and Hedy Lamarr on hand helping to raise a billion dollars to "Keep 'em Flying" and "Keep 'em Rolling." Some patriotic Americans never cashed in their War Bonds, feeling the money they gave was a personal sacrifice for defense purposes. By 1945, eighty-five million people, over one-half the population of the United States, held War Bonds. War Bond posters issued by the U.S. Government also helped to inspire patriotism and prompted bond buying. Simple direct slogans like "Back the Attack" were imprinted on posters, magazines, book covers, matchbooks, sheet music, and candy wrappers. They turned up almost everywhere you looked, encouraging people to go out and buy United States War Savings Bonds and Stamps.

★ ★ ★

[OPPOSITE] *Blackout Kutouts with images that glow in the dark,* published by the Vernon Company of Newton, Iowa, 1942.

[BELOW] *Civilian Defense Index booklet,* compliments National Starch Products, Inc.

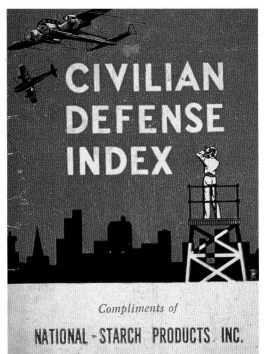

RESIDENT ROOSEVELT CREATED THE Office of Civil Defense in May of 1941. The purpose of the Civilian Defense Corps, the "CD" as it was most often called on the World War II home front, was to instruct American citizens in activities that would help protect their homes and families during an air raid or in the event of an enemy attack. New York City's Mayor Fiorella LaGuardia was appointed the head of this government office with Eleanor Roosevelt functioning as his assistant. There were over twelve million volunteers (one million less than were in the Armed Forces) carrying out Civilian Corps duties. Civilian Defense gave volunteers the opportunity to serve in many different ways: a citizen could become a CD Air Raid Warden, a Driver's Corps messenger, an auxiliary policeman, an auxiliary fireman, a fire watcher; or a member of a bomb squad, a road repair crew, a decontamination squad, a demolition and clearance crew; or part of the Emergency Food and Housing Corps, the General Staff Corps, or the Medical Corps and Nurse's Aides Corps who could administer first aid.

During air raid drills active members of the Civilian Defense Corps Air Raid Wardens, wearing their metal hats and armbands, could be seen on the darkened streets of a town or city making sure lights were out and blackout curtains were drawn in every house. Only after radio alerts or sirens were sounded could they leave their posts and return home. The Office of Civilian Defense was discontinued in late 1943 once the threat of an invasion of the United States was deemed unlikely. Nevertheless blackout restrictions continued and air raid alerts and drills were in effect for the war's duration.

Hundreds of uses for BLACKOUT★ KUTOUTS

THE NEW WONDER MATERIAL
Glows in the dark

FOR FUN

FOR UTILITY

FOR THE BLACKOUT

PRACTICAL • INSTRUCTIVE • MYSTIFYING • FUN

★ ★ ★

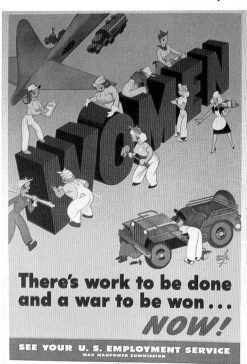

[BELOW] *"There's Work to Be Done and a War to Be Won . . . Now!"*
U.S. Employment Service, War Manpower Commission. (Meehan Military Posters)

𝒯HE WOMEN ON THE home front who went to work in defense plants became known as "Rosie the Riveters" or as "Winnie the Welders." These "defense plant patriots" were out to show their stuff in answer to enemy characters like Tokyo Rose (whose real name was Iva Ikuko d'Aquino, "the seductive Jap of the radio airwaves"). There were many "Tokyo Rose" imitators during the war years, as well as the equally pernicious "Axis Sally" who broadcasted propaganda on the European front. These notorious women were renowned for their attempt to undermine American soldiers and their battlefront goals by creating nasty scenarios about what was supposedly going on back home with a sweetheart or wife. The primary propagandist theme would suggest that a loved one at home was no longer faithful or that she had taken up prostitution.

With men away at war many wives and sweethearts could no longer stand the loneliness and frustration of just waiting at home, keeping the home fires burning. Even women who doubled as homemakers put their tots in day- or night-care centers, rolled up their sleeves, dressed in coverall jumpsuits, and went to work armed with the slogan "We Can Do It!" These "Rosies" certainly proved that they could do the job as well as any man and were considered home front fashion plates in their new jumpsuits and sturdy work shoes. With their hair tied up in turbans, kerchiefs, or snoods, or wearing a steel welder's helmet they worked with motor drills in hand on assembly

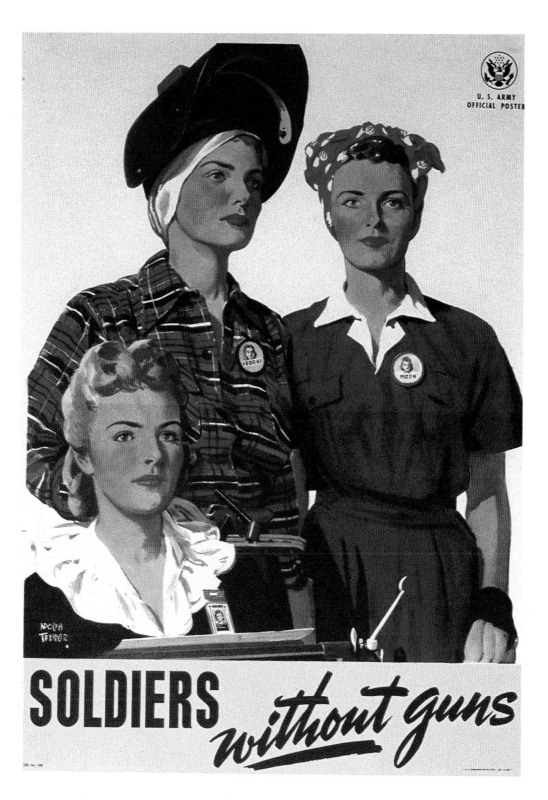

[LEFT] *"Soldiers Without Guns,"* U.S. Army official poster, art by Adolph Treiner, USGPO, 1944. (Meehan Military Posters)

lines in woodshops, as welders, in radio assembly, as ground mechanics for aircraft, as airplane construction punchpress operators, and on the drill press. They learned to curse and holler alongside their tough middle-aged redneck co-workers. Defense plant workers came from all over; both male and female, full- and part-time—some were even teenagers.

The label "Rosie the Riveter" originated with an airplane factory worker named Rosina Bonavita. It became the catch-all phrase for all women in defense work in the 1940s. Five million women worked in industry during the war. Three hundred and fifty thousand women joined the military; by the end of the war there were two hundred and eighty thousand "Dames for Defense" still on active duty.

Out of economic necessity, the war on the home front brought with it more casual lifestyles for men and women. Many women still functioned as homemakers and housewives who kept the family centered. In their spare time, however, they became local Red Cross workers or joined civilian defense auxilliaries like the American Legion, which took pride in its two million female members.

For recreation and relaxation workers went out to bars and dance halls which were always jammed full. Women learned to drink heavily and smoke incessantly along with men, bonding together under the stress of living through a war. Those who worked the swingshift (4 P.M. to 1 A.M.) toiled through the night imagining the day-shift crew having a ball "swinging it" at local bars and dance halls or at the U.S.O. Thus the term "swing-shift" became a popular term. Not everyone went out after work; some used their leisure time to relax at home, enjoying the quiet or perhaps listening to the radio each evening.

[RIGHT] *Frances Wright,* San Francisco Bay Area war worker, models the defense plant look for women.

The Bugler's Call

UNCLE SAM WANTS YOU!

★ ★ ★

*I*N SEPTEMBER 1940, JUST two months after the fall of France, the Selective Service Act was passed in Washington, D.C. Adult males between the ages of twenty-one and thirty-five were required by law to register for the draft. Failure to comply meant facing arrest, possible imprisonment, or stiff fines. With Army General Lewis B. Hershey at the helm, the Selective Service Administration set up over six thousand local draft boards run by volunteers in local town halls, village community centers, city halls, Grange halls, and schools. Young men, when they reported, would be given a registration certificate after filling out a Selective Service questionnaire and later would receive a classification notice in the mail. Lots drawn by a number system were assigned to registered men who, after a physical examination and psychological testing, were inducted into the Army. Being drafted meant eight hard months of boot-camp training before being shipped off to active duty or some kind of special assignment. Men who were already in National Guard units did not waste time in joining up—they too registered at local draft boards. After the war officially began many enthusiastic young men with draft boards breathing down their necks enlisted in the U.S. Navy, lured by promises of Pacific South Sea adventures, or joined the Army Air Force which promoted the dramatic idea of air combat. The AAF members were referred to as America's "Cowboys of the Sky" because of the inherent danger involved in flying an airplane in wartime skies. The many different squadrons and bomber crews, with their individual colorful insignia, functioned almost as a family unit. The hand-painted nose-art on planes

[ABOVE] *"He's 1-A in the Army and He's A-1 in my Heart,"* Johnny Long and his orchestra, vocal by Helen Young, 78 rpm Decca record.

or on the back of a leather jacket had a reckless daredevil appeal to men looking for excitement. An A-2 or G-1 leather flight jacket became a wearable emblem of courage; and some, like the Flying Tigers' jackets sporting Japanese Rising Sun flags signifying the number of enemy planes the pilot had downed, became instant trophies of combat and survival to be cherished decades after the war was over. Still other young men went for a stint in the tough leatherneck Marine Corps with its stunning uniforms, especially those of higher rank. Some recruitment posters emphasized the appeal a man in a uniform would have to a U.S.O. dance hostess or to a Hawaiian hula girl.

Following the Pearl Harbor attack the draft age for men widened from eighteen to forty-five. In some areas of the country, men from forty-five to sixty-five were actually registered with the Selective Service, though those over thirty-five were never inducted. Married men in general were exempt although many eventually joined one service unit or another out of a sense of patriotic duty.

Eleanor Roosevelt and Maine Senator Margaret Chase Smith felt women should do their active part in the service. Old-fashioned congressmen felt a woman's place was in the home, ignoring the fact that women had been at work in the private sector since the industrial revolution. In 1942, America took a step toward women's liberation when all non-combat military services were opened to women.

The Women's Army Auxiliary Corps, or WAACs, existed until 1943 when it was shortened to WACS, or the Women's Army Corps. WAVES was the acronym for "Women Appointed for Voluntary Emergency Service," a cadre of women who, after July 31, 1942, had been accepted for voluntary service in a branch of the U.S. Navy. To be eligible, a WAVE had to be able to swim at least fifty yards. The WAVES recruited one hundred thousand women for military service. SPARS were the Coast Guard

[OPPOSITE] *U.S. Navy recruiting booklet.*

[BELOW] *WAC recruiting poster* contributed by Wamsutta Mills, New Bedford, Massachusetts. (Chisholm Gallery)

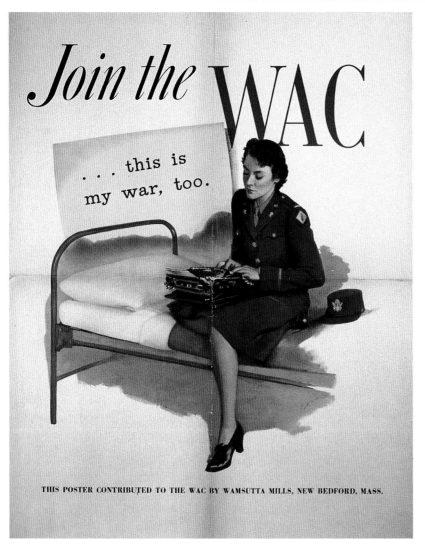

Join the WAC

... this is my war, too.

THIS POSTER CONTRIBUTED TO THE WAC BY WAMSUTTA MILLS, NEW BEDFORD, MASS.

MEN MAKE THE NAVY

...THE NAVY MAKES MEN

▶ FIGHTING ACTION
▶ EXPERT TRAINING
▶ 49 SKILLED JOBS
▶ GOOD PAY

▶ QUICK PROMOTION
▶ GOOD FOOD & QUARTERS
▶ GOOD SHIPMATES
▶ FOR MEN 17 TO 50

[ABOVE] *Wartime match-book* warning servicemen against prostitutes and VD.

Women's Reserve who volunteered to serve in the U.S. Coast Guard. Special women's branches were included in the Marine Corps but no special tag or special consideration was given to them. WAFS were the Women's Auxiliary Ferrying Squadrons. WASPS, or Women's Air Force Service Pilots, were not officially recognized until 1979 when, thirty-four years after the war ended, they were given official discharges and veterans benefits by the Assistant Secretary of the Air Force. Many of the 1,074 women who completed the program (25,000 applied and 1,830 were selected, of which 756 served as back-ups and in administration jobs) flew every type of plane, including B-29s and B-17s. Thirty-eight WASPS lost their lives in crashes while ferrying planes to military bases. Women in the military were only allowed to relieve men of administrative tasks and clerical jobs; but many women proved they could perform the same active combat duties as well as their male counterparts.

By the middle of 1943, the Army and the U.S. Army Air Force (AAF) had 7,700,000 men and women in uniform. This number increased to 8,300,000 by the end of the war. In 1945, 3,400,000 men and women were in the Navy. There were 484,000 members of the Marine Corps and 170,000 were in the Coast Guard.

A great deal of wartime life in the service was spent in the barracks or in quonset huts, waiting for the inevitable call to action or duty. Getting up at the crack of dawn to the bugler's call for training sessions, marching drills, or to salute and stand at rigid attention left a serviceman nervous and exhausted at the end of the day. Some troublemakers might wind up on K.P. (kitchen patrol) duty peeling potatoes or in the brig if he did not behave according to military regulations. Letters, postcards, greeting cards, and "care" packages from home were eagerly awaited. "Mail call" was the highlight of every soldier's day. Some packages might include mother's homemade brownies or fudge for passing around to other G.I. Joes—or it might contain a hand-knit scarf or a pair of socks made according to Army standards. Another gift might be a servicemen's shoeshine kit, a new paperback book, a magazine, or that special photograph of a loved one in a stand-up cardboard frame.

Specially prepared military-issued pamphlets and booklets warned more innocent soldiers, some of whom were just gawky farm boys, about venereal diseases they could contract while on leave if they visited a prostitute or went off with one of a number of promiscuous women who hung out at local bars just off the base. Some aggressive prostitutes set up trailer camps, soliciting sex near a military base. Sailors, soldiers, and marines were duly warned about this in booklets with titles like *Sex and This War.* A weekend pass might mean drinking and carousing with a group of buddies or going to a special servicemens' dance. For many, if it was a long furlough of a week or two, it might mean a

chance to head home for a visit to a sweetheart, a wife and children, or to enjoy Mom's home-cooked meals and a good-night's sleep in the bedroom that Mom always kept ready and waiting. These home reunions were always filled with sentiment and the all too few precious moments were savored and enjoyed. Once back at the camp or shipped overseas on active duty, a soldier had only the memory of "A Fellow on a Furlough" to get him through. However, loneliness gave way to determination to win the grim fight ahead which was necessary to keep Democracy and the folks left behind on the home front safe from harm.

[BELOW] *"Sex and This War"* booklet for servicemen by Winfield Scott Pugh, M.D. and Edward Podolsky, M.D., Simon Publications, Inc., New York, 1942.

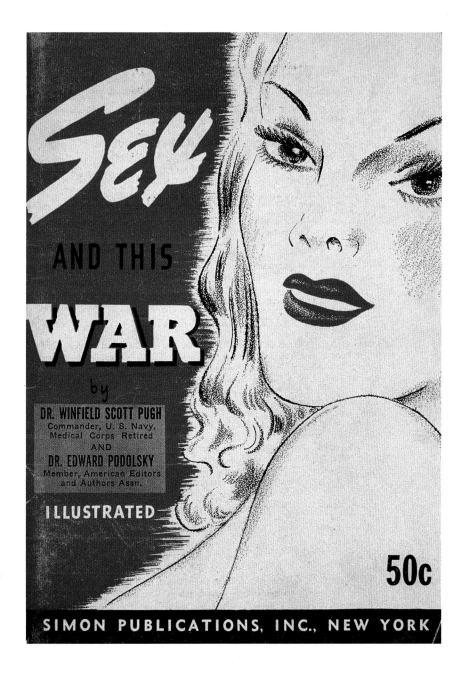

★ ★ ★

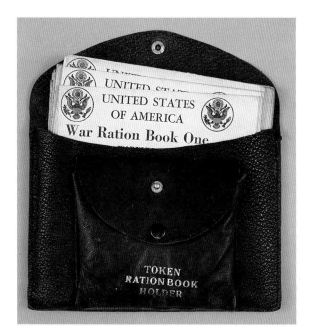

[BELOW] *Leatherette token and ration book holder with War Ration Book One series.*

RATION BOARDS WERE ESTABLISHED in towns and cities across America by the Office of Price Administration, or OPA. Ration books with sheets of perforated stamps organized into various categories, such as gas, sugar, and meat, were given to citizens who registered with the Board. Millions of these booklets with stamps were printed by the Government Printing Office. The "Golden Rule of Food Rationing," according to a *Victory Cookbook* featuring the uses of wartime ingredients, included seven handy suggestions:

1] Share your food with our fighting men.

2] Shop early in the day, early in the week, to lighten congestion in the store.

3] Make up a shopping list and add up the points BEFORE you shop. Include fresh fruits and vegetables, cereals, and other unrationed foods where you can.

4] Plan your family diet carefully. Get enough nourishment. Make up menus for the week.

5] Use 8- and 5-point stamps when you can, save 1- and 2-point stamps to make the count come out even. Your grocer cannot give you change in Blue Stamps.

6] Do all the home canning possible.

7] Don't blame your grocer for wartime inconvenience.

The rationing point system, with its tiny color-coded stamps and red and blue cardboard tokens, created anxiety for housewives and drove grocers to distraction.

An example of the wartime point system for food, which had to be paid for in both cash and stamps or tokens went as follows:

PRODUCT	AMOUNT	POINTS
Pork chops	1 lb.	7
Hamburger meat	1 lb.	7
Ham	1 lb.	7
Lamb chops	1 lb.	9
Butter	1 lb.	16
Oleomargarine	1 lb.	4
Dried beef	1 lb.	16
Canned sardines	1 lb.	12
Cheddar cheese	1 lb.	8
Condensed milk	1 can	1
Pineapple juice	46 oz. can	22
Baby food	4 ½ oz. jar	1
Tomato catsup	14 oz. bottle	15
Canned carrots	16 oz. can	6

Housewives soon began to sing their own version of "The Sugar Blues" in reaction to the hard-to-get commodity. The ditty went:

"I hate to see
My sugar stock go down,
So little white
And very little brown."

The *Ladies' Home Journal* of July, 1942, explained to their readers why sugar had to be rationed: "Sugar cane is needed to make molasses. Molasses is used to make industrial alcohol which is needed to make explosives. Explosives are needed to sink the Axis!" Vegetables were relatively plentiful during the war and so the OPA's Food Rationing Division could keep that point system much lower than, say, meat or coffee. Liquor was hard to get and this led to black marketeers who brewed their own whiskey blends—which occasionally proved lethal. As they did in the 1920s and 1930s, whole segments of the population, under the constant wartime strain, drank heavily whenever they had the

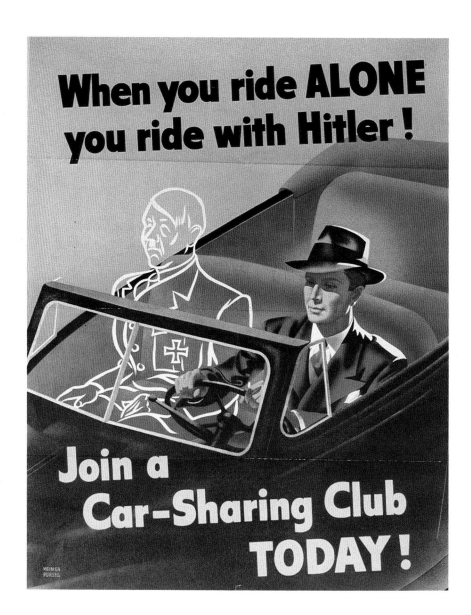

[ABOVE] *"When You Ride Alone, You Ride with Hitler,"* poster by Weimar Pursell. (Meehan Military Posters)

[BELOW] *U.S. Office of Price Administration gasoline ration card,* state of New Jersey.

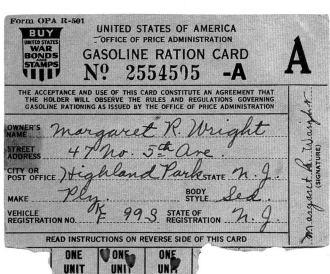

opportunity and alcoholism was rampant. Shoes were rationed to three pairs per year, though most citizens tried to keep what they had in steady repair, taking them to the shoemaker to be resoled or reheeled rather than buying new ones. Nylon stockings were rationed, although they too were a profitable sideline for black marketeers. Many women took to wearing cotton socks or slacks out of necessity. The OPA asked restaurant or diner customers not to embarrass waiters or waitresses by asking for that extra "pat" of butter or margarine, and further urged diners, "don't ask for a refill on your coffee."

The last automobiles manufactured in the United States for civilian use rolled off the assembly lines in February, 1942. By spring of that year the first gas shortages hit the East Coast. By mid-May over eight million motorists were required to register for gas-ration cards. The OPA decreed in January, 1943 that pleasure drives were prohibited for the duration. Windshield sticker letters from A to E had a variety of color backgrounds denoting a car's allowable usage. The categories included: A, non-essential for war driving; B, for commuters who drive to work but do not use their vehicles on the job; C, salesmen and delivery driving—work related; E, emergency vehicles which included clergy, police, firemen, press photographers, and journalists; T, truckers, work related; X, congressmen. This "X" category required no rationing at all and naturally brought widespread criticism and griping.

[BELOW] *Novelty V-Sugar Ration Spoon* has hole in the V for Victory shape. Souvenir of Minneapolis, Minnesota.

In addition, a rubber shortage slowed things down to the 35-mile-per-hour speed limit mandated by the government. A slogan from a used-car dealer stated: "Your automobile is a weapon of war—it is your duty to keep it constantly in shape to serve your country's wartime transportation system."

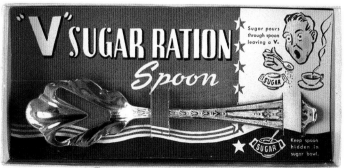

★ ★ ★

HOUSEWIVES WERE TOLD BY the War Production Board to save waste fats from their kitchen for explosives. Most were only too happy to institute this practice, feeling it was one small service they could perform to help in the war effort. Songstress Mildred Bailey recorded a song called "Scrap Your Fat"; and it was played often on the radio to get the idea into motion. A wartime bulletin handed out at butcher shops and local markets read:

1] THE NEED IS URGENT—War in the Pacific has greatly reduced our supply of vegetable fats from the Far East. It is necessary to find substitutes for them. Fat makes glycerine. And glycerine makes explosives for us and our Allies—explosives to down Axis planes, stop their tanks, and sink their ships. We need millions of pounds of glycerine and you housewives can help supply it.

2] DON'T throw away a single drop of used cooking fat, bacon fat, meat drippings, fry fats—every kind you use. After you've got all the cooking good from them, pour them through a kitchen strainer into a clean, wide-mouthed can. Keep it in a cool dark place. Please don't use glass containers or paper bags.

3] TAKE THEM to your meat dealer when you've saved a pound or more. He is cooperating patriotically. He will pay you for your waste fats and get them started on their way to war industries. It will help him if you can deliver your fats early in the week.

Some butcher shops offered two red ration-points for every pound of used fats. There were official fat collecting stations, stores which hung an official poster to that effect in their windows. *Liberty Magazine* of December 5, 1942, had an advertisement soliciting housewives and restaurant cooks to save fats. The headline read: "Helen Hayes shows the Navy how she saves *waste kitchen fats* to help stop Japs." An accompanying

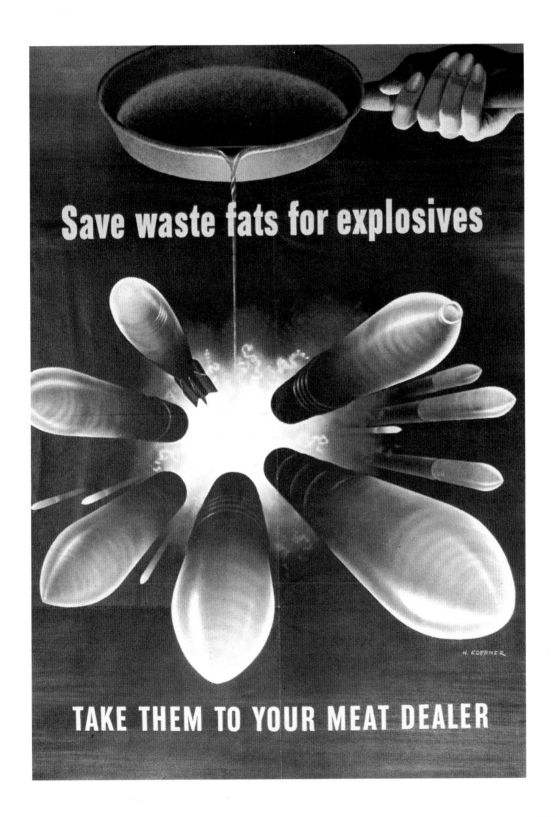

photo showed Hayes in the kitchen of her Nyack, New York, home demonstrating to two handsome sailors how she strains fat into a can. She is quoted as saying, "I'm told that a single pound of kitchen grease will make two anti-aircraft shells. So you can bet that not one drop of waste fat in my house ever goes down the drain. Instead I send it back to my meat dealer—and on its way to war. I'm making it a wartime habit—are you?" Another photo shows the smiling actress looking every bit like an average American housewife complete with gloved hands, handing a one-pound tin of fat to a beaming butcher.

Other materials officially collected for national defense included tin and aluminum in the form of cans and foil. Tin cans were melted down and cast into solid metal "pigs" for re-using in war industry. There was a great need for rubber after supplies from the Dutch East Indies were no longer available. Rubber scrap drives collected old tires by the millions; usable tires for automobiles had to be retread again and again until they were deemed unsafe.

Nylon and silk stockings were turned in at salvage drives across the country. Large barrels were set up in department stores, schools, offices, and factories to collect old silk and nylon. Silk was reprocessed for parachutes and nylon was used for tow-ropes, among other things.

Vast amounts of scrap metal, car fenders, metal bars, old pipes, oil barrels, and the like were loaded into huge vans and dumped into fenced-in vacant lots to be recycled into planes, tanks, ships, and guns for ammunition. President Roosevelt sent an official White House letter to Boy Scout and Girl Scout groups in 1942, urging them to participate in scrap drives. The letter read:

> "Boys and girls of America can perform a great patriotic service for their country by helping our National Salvage effort. Millions of young Americans, turning their energies to collecting all sorts of scrap, metals, rubber, and rags can help the tide in our ever increasing war effort. They will earn the gratitude of every one of our fighting men by helping them to get the weapons they need—now! I know they will do their part."

While some children hated to turn in their metal toy cars and trucks or old *Superman* or *Captain Marvel* comic books they did so anyway out of a sense of patriotic duty. Many participated in collecting newspaper and magazine "waste paper" which was also needed in the defense effort. Salvage yards were in every neighborhood and American kids delivered the goods to help win the war, often carrying banners which read, "Slap the Jap right off the map by salvaging scrap!"

[OPPOSITE] *"Save, Serve, Conserve—Schools at War,"* poster painted by Irving Nurick, sponsored by the War Savings Staff of the U.S. Treasury, Department of U.S. Office of Education and Its Wartime Commission, 1942. (Chisholm Gallery)

Home Sweet Home Front

VICTORY GARDENS

★ ★ ★

"Working in a garden is a wonderful sedative for those 'war nerves.' "
Good Luck Gardens Seed Catalog, Paradise Pa.

MANY AMERICAN FAMILIES PLANTED and tended their own Victory gardens to offset expected wartime food shortages during World War II. Saving money for the home front war effort and a sense of patriotic duty were primary motivations for many families. Millions of small-town backyard and city rooftop gardens suddenly sprouted up across the country in the early 1940s. Some neighborhood groups selected a vacant lot for growing, taking turns working the garden and forming food cooperatives which distributed produce to the needy. Those who owned and worked a farm as an occupation were required by the government to set aside at least one acre of land to grow vegetables for their own family or to sell at cheap rates at established farmers' markets and roadside food stands. First-time amateur gardeners soon found out the tremendous work and attention involved in growing their own vegetables; but they also experienced that sense of joy and fulfillment when a seedling began to grow.

Victory garden information could be obtained from the U.S. Department of Agriculture. Booklets on how to grow your own Victory garden were printed by the government and distributed free; some were sold for 10¢ by companies like International Harvester or the Beechnut Packing Company. Countless books on wartime gardening were available from commercial publishers with titles like *Gardening for Victory, Food Gardens for Defense, Grow Your Own Food to Feed Your Family,* or *25 Vegetables Anyone Can Grow.* Posters and dozens of articles in magazines encouraged patriotic Americans to plant that Victory garden, spurring people to harvest and share their own bounty. Movie magazines featured stars like Joan Crawford hard at work in their Victory gardens, inspiring others to do the same in

their backyards. It was reported that Crawford favored growing hearty vegetables like beets, cauliflower, carrots, and squash and had a special section devoted to a variety of red, yellow, and white tomatoes. Special guests invited to Crawford's home were served what she called her "Mildred Pierce Victory Salad" with all ingredients grown in her own garden.

During peak war years there were an estimated twenty million Victory gardens growing in the United States, producing over one third of the vegetables available in the country. Victory garden instruction booklets made note of the necessary attention to soil conditions and recommended a well-pulverized soil. A healthy Victory garden, according to the pamphlets, required proper seedbed preparation, good plowing or spading and harrowing, and raking. The materials needed for successful gardening: shovels, spades, rakes, watering cans, bug sprayers, and at least a thirty-foot garden hose were advertised as tools that should be purchased by a beginner. Learning to control fertilizer use and weeds became a necessity in this "grow your own garden" process. Victory gardeners soon became experts at which sprays to use against certain garden pests such as cabbage worms, caterpillars, squash bugs, aphids, thrips, leafhoppers, the striped cucumber beetle, or Japanese beetle. The latter were annihilated with a special vengeance. Special sprays were created to scare off rabbits without harming them and scarecrows were put up to chase away blackbirds and aggressive jaybirds. Some of the Victory garden scarecrows were fashioned to resemble Hitler, Mussolini, or Hirohito.

Springtime planting opened up to the splendid abundance of summer and the happy harvesting of autumn. In preparation for the winter enjoyment of summer's bounty, mother would ready her special deep cooker-canning pot designed to hold a number of glass Mason jars; some women used pressure cookers to speed up the process and conserve fuel. The jars, filled with cooked produce, had to have sterile rubber rings and either metal or glass tops which were tightly sealed. Fruit jams and jellies were topped with hot wax, sealing them for cellar-pantry storage. Stewed tomatoes, corn relish, and chutneys were "canned" and "jarred" from homegrown gardens and were enjoyed in many "Wartime Recipes" throughout the year.

Home Sweet Home Front

WARTIME MENUS

★ ★ ★

*I*N PREPARATION FOR HER wartime food menus a homemaker had to keep the weekly budget, rationing restrictions, and scarcity of certain items in mind. Home cooking usually had to be quick and simple; but meals also had to be hearty, particularly if a family member worked long hours at a defense job. With all the extra activities on the home front, and with the possibility of a soldier, sailor, or marine coming home for a furlough, preparing and presenting an attractive wholesome supper could become a chore. Careful planning of meals was a necessity. In some sections of the country patriotic "meatless Tuesdays" were instituted. Thrifty shopping in the 1940s could be accomplished at larger chain food markets like the Piggly Wiggley, the Grab-It-Here stores, the Food Fair, Hinky Dinky stores, the Big Bear, or the old standbys like Gristede's, the A&P, Food Town, the Acme, or Safeway.

Wartime menus in the April, 1942 issue of *Good Housekeeping* magazine emphasized meat recipes for Creole Liver, a Spanish meat-rice concoction, or a spaghetti-pork-chop combination served in a casserole. Canned peas or buttered broccoli were the recommended vegetables with mashed potatoes and gravy added to make a balanced meal. Gussied up sauces, garnishes, or canned pineapple slices might take the focus off the low-cost wartime menu ingredients. Baked meatloaf became a standard offering in wartime, as did a meal of canned baked beans served with "franks" or "Spam." The Hormel "Spiced Ham" product called "Spam" came in a compact rectangular can and in addition to home use could be easily shipped overseas to the British or used as the main entrée for a meal on a battleship or submarine. Spam was also included in servicemen's rations on the battlefronts. Home front housewives served up Spam in a variety of interesting ways, many of which were inspired

[BELOW] *Milk pamphlet* "Victory" Recipes in the Wartime Diet from Borden's Farm Products, 1942.

The ☀ Sun
NEW YORK

WAR TIME
Cook Book

MENUS, RECIPES AND CANNING INFORMATION
TO HELP MAKE YOUR RATION POINTS GO FURTHER

25¢

By

EDITH·M·BARBER
FAMED FOOD EDITOR OF THE NEW YORK SUN

directly by the ads Hormel put in magazines like *Woman's Day* or the *Ladies' Home Journal.* Baked Spam with canned Spanish rice, Spam fried in Spry or Crisco with creamed corn and potato salad, or Spam "Aloha" with sliced pineapple and avocado were some of the attractive offerings the wartime family had to contend with. In all, Hormel produced two hundred and seventy-two million pounds of the product G.I.'s deemed to be the most hated of all canned "luncheon" meats during the war years. Returning veterans would usually refuse to eat Spam at home when it was served by a mother or wife.

Design and presentation were all-important in food preparation. A July 4th patriotic red, white, and blue table-setting illustrated in the *Ladies' Home Journal* of July 1942 accompanied an inspiring article by Ann Batchelder entitled "Let Freedom Ring!", in which the great virtues of the Declaration of Independence and the importance of being a good American in trying times were extolled. The illustrated menu, which cost $3.40, served six and included at least two dozen thin-cut porch chops described as "Victory Ham," a red vegetable broth, new potatoes, watercress and asparagus with melted butter, and sliced tomatoes and coleslaw arranged on a blue platter to resemble the red and white stripes of the American flag. Star-shaped baking powder biscuits and fresh strawberries in a honey-snow bank of whipped cream topped off this meal with yet another patriotic touch.

The floral centerpiece completed the setting: an arrangement of red poppies, white carnations, and blue bachelor buttons. The glass tumblers, napkins, and other table accessories are American red, white and blue; and the tablecloth a field of bright scarlet. Such fussing, particularly for holiday partying, could be a welcome relief from wartime blues; besides there was always Thanksgiving or Christmas to look forward to, when roast turkey and real baked ham were served with plenty of bowls filled with stuffing, potatoes, vegetables, cranberry sauce, and other side dishes. At these special holiday times or at Sunday dinner, home-baked apple, pumpkin, or mince-meat pies were served with fresh perked A&P or Maxwell House "good to the last drop" coffee. During the week desserts might consist of Jell-o or package-prepared tapioca or chocolate pudding with dried coconut sprinkled on top. On special occasions, Kate Smith's famous Swan's Down double-layer cake with thick pink, white, or chocolate icing might be served.

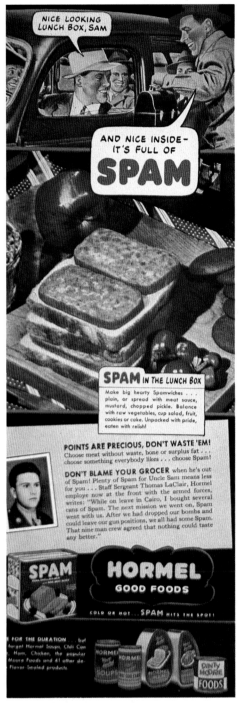

[ABOVE] *Spam,* the canned meat product from George A. Hormel & Co., Austin, Minnesota, advertisement from Life magazine, October 28, 1942.

[OPPOSITE] *The New York Sun Wartime Cookbook* by Edith M. Barber, 1943.

Suppertime was always something to look forward to in those wartime years and mothers always made sure that everyone in the family was well fed. Whatever was left over turned up the next day as hash, usually served over homefries, elbow macaroni, or rice. *Woman's Day,* a magazine which, in the 1940s, sold for 2¢ at all A&P foodstores, included in its March, 1944 issue a three-page section called "Wartime Cooking." A week of low-cost menus and recipes was offered for two moderately active adults and two children between the ages of ten and twelve. The cost for a week, including breakfast, lunch, and dinner, was thirteen dollars for this family of four. Some of the items featured for dinner were a liver-and-sausage loaf (55¢), quick tomato cheese puffs (29¢), and stuffed breast of veal (89¢). Steak, bacon, or prime meats were noticeably absent from the magazine's wartime weekly plan. Coffee was suggested for the adults while children got milk. Desserts like Indian pudding, butterscotch pudding, and Norwegian prune pudding, were all made from a pre-mixed and boxed product.

ealthy!

...ched

WARD'S
TIP-TOP
BREAD

Enriched

TO MEET TODAY'S DEFENSE NEEDS FOR VITAMIN B-1 AND MINERALS
AS RECOMMENDED BY NATIONAL RESEARCH COUNCIL

...with extra
VITAMINS
and MINERALS

Is your dog at his best on his present wartime diet?

Eyes dull? Hair shedding?
No pep? Breath bad?

Dogs do better on PARD

Home Sweet Home Front

HOME FRONT DECOR

★ ★ ★

*T*HE GREAT FRANK LLOYD WRIGHT, Richard Neutra, and other forward-looking architects created new exciting futures for American homes and for lifestyles in the early 1940s. Structures were designed and built to blend into natural surroundings. This style and execution was available only to the elite strata of society until after the war. A bogus form of this aesthetic philosophy—The Ranch House—became popular among veterans because they were cheap to construct. Most of the homes American families lived in during the 1940s were still in the Colonial, Tudor, or "Three Little Pigs" brick-and-cement Humperdinck style if they were not two-family wooden barnlike structures like those that still stand in some American cities. Turn-of-the-century houses in cities like New York or Philadelphia stood one right next to the other (as they still do today) with an occasional break for a "newer" 1920s "Gingerbread" or 1930s Art Deco apartment building. Small box-like pre-fabricated houses were cheaply and efficiently constructed for military personnel and their families during the war and many continued to live in these "Quonset huts" in the post-war era.

Good Housekeeping of April, 1942, featured "decorating miracles" in an article entitled "We Decorate a Defense House." Burnsford Homes, Inc. had erected a series of "Defense Houses" in the industrial town of Bridgeport, Connecticut, building them on small lots of 50-by-100 feet.

The houses were identical, using one story with an attic, a precursor to Levittown, Pennsylvania where the houses all looked the same. On the ground floor there was a living room, a combination kitchen-dining room, a child's bedroom with

Better Homes & Gardens

MORE THAN 2,400,000 CIRCULATION

JULY 1942 **15¢**

★ Home is the
Strength of the
Nation

PLANNING FOR TODAY AND TOMORROW—Page 18

SUMMER COOK BOOK – Frosty drinks · Steps to canning · Meals-in-a-basket · and more

double-deck bunkbeds, and a bedroom for mother and father. The attic area was converted by the magazine's decorator, Dorothy Draper, into a sitting-room/play-room combination which could eventually become a baby's nursery. For nine hundred dollars this tiny Defense House was revamped with "no waste space" and decorated in striped wallpaper and floral chintz drapes, chair coverings, and accents. Included in the price plan were a dining-room table and chairs, a kitchen dinette set, a living room bed-sofa, two over-stuffed chairs, a desk, a coffee table, two lamps, wall pictures, rugs, a radio-phonograph console, a double bed, bunk beds, curtains, linens, towels, and many other pieces. The overall effect was Colonial style, a look reproduced extensively in the 1940s for its homey, intimate atmosphere. The same house had a small backyard big enough for a Victory garden, a family picnic table, a fruit tree, an outdoor brick fireplace grill, and a grape arbor.

[ABOVE] *Soldier's souvenir pillow "To a Friend,"* satin with fringe.

The decor of 1940s interiors was usually a mix-and-match affair with modernity or stark bent-ply-wood furniture still considered odd-ball by most middle-class housewives. These homemakers functioned as the primary interior decorator, buying their over-stuffed mohair living room furniture and thier patterned rugs and floral draperies at department stores and through catalogs. Dad would hang scenic, leafy, or floral wallpaper in the living room or dining room. The color could be dark reds, forest green, or navy blues, replacing the more subtle 1930s Deco "look." Since mother liked to crochet while listening to the radio, the backs and arms of chairs would be covered with doilies and antimacassars. Likewise, pictures on the wall might be hand-embroidered samplers with country and garden scenes and homey sayings like "Let Me Live in the House by the Side of the Road and be a Friend to Man" or just a simple "Bless This House." A framed Maxfield Parrish of print nude nymphets reclining, sitting, or stand-ing in a dreamy Shangri-La–type mountain forest and blue-lake setting might hang over the fireplace mantle, in the dining area, or in an alcove-entranceway.

The kitchen of the 1940s was the exception to the rule. After the Depression-green or dark cream of the 1930s, magazines like *Better Homes and Gardens* or *House Beautiful* confided that kitchens could now be painted cherry red or canary yellow.

Colorful venetian blinds and Armstrong linoleum with matching curtains could be found to coordinate with the new cheerful color of the walls. Sometimes kitchen wallpaper would feature pots of red geraniums or vivid Mexican patterns which reflected the "South-of-the-Border" good-neighbor policies that were a vital aspect of the war years. Dishware might also be in bright

[ABOVE] *Bedspread and drapery wartime-theme fabric for a boy's room,* Bates & Co., New York.

Mexicana or Fiesta colors. Kitchen tables and chairs lightened up from the dark woods of the 1930s to the chromium steel leatherette and formica countertops which came into vogue in the more streamlined decor of the 1940s kitchen.

During wartime, Junior's room might be wallpapered with red, white, and blue bomber planes and battleships. Likewise the Bates Company of New York and others produced cotton bedspreads and matching drapes in red, white, and blue featuring patterns of Fighter Squadron planes and fleets of naval ships. If there was more than one boy in the family, decorating magazines of the period would suggest bunk beds that emulated the Army-Navy barracks style, instead of twin beds. Special war-theme linoleum patterned with war maps, tanks, bombers, and flags could also be utilized in a boy's room, playroom, or den.

Bric-a-brac, like double vases in the shape of a "V for Victory" symbol or painted statuary of a soldier, sailor, marine, or their female counterparts, could be found in the living room on knick-knack shelves or on the radio console. Painted-on-reverse glass stand-up dime store frames in red, white, and blue with the slogans "Keep 'Em Flying" or "Keep 'Em Rolling" might be put on a bureau in the bedroom or on a living-room table. A mood lamp of chromed pot-metal placed on an endtable or on top of a bar might be in the shape of a dive-bomber or some other war aircraft. In addition, a kitchen tablecloth or a set of glass tumblers might have a patriotic design incorporating eagles, flags, or "V for Victory" symbols and would be brought out when groups like the "Mothers of Servicemen in Foreign Wars" came over for A&P Bokar coffee and homemade crullers.

Emerson Radio and Phonograph Company of New York put out a flag-inspired Monsanto plastic table-model radio called "The Patriot" in three color combinations of red, white, and blue. Displays in radio shops offered the three different varieties—solid white with red grill, knobs, handle, and a blue dial; solid blue with red grill, knobs, handle trim, and a white dial; or solid red with a white grill and a red, blue, and white dial—all together on an Uncle Sam "Hat" display stand. During the war years the Fada Radio and Electric Company of Belleville, New Jersey, came out with its answer to "The Patriot," a version of its popular streamliner baby radio in the aerodynamic rectangular teardrop style (one square side and one side with an automotive curve). Fada called its model 189 "The All American" but it was also referred to as "The Victory Radio." It was of solid white molded Catalin with a thick rim of navy blue set around the dial front and with red knobs and a red handle. These small novelty radios glowed on a bedroom night table or on a kitchen counter and always gave an extra meaning to the word "patriotic" when you were listening to Major Glenn Miller on one of his Army Air Force Band broadcasts playing a war tune like "The Victory Polka" or "Enlisted Men's Mess."

A litho-on-metal Kate Smith "God Bless America" clock made in Chicago as a novelty item might be found on top of the refrigerator or in the den. It depicted the Statue of Liberty against a map of the United States with the clock's numbers set against red stars.

The main image and symbol of patriotic duty and service in a "Victory" home during World War II was the red, white, and blue rectangular star banner that hung in the window to show that a family had a boy in the service.

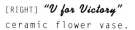

[RIGHT] *"V for Victory"* ceramic flower vase.

[OPPOSITE] *Wartime travel poster* showing mother and serviceman's banner behind her. Office of Defense Transporation, 1944. (Chisholm Gallery)

"Won't you give my boy a chance to get home?"

DON'T TRAVEL — unless your trip helps win the war

U. S. OFFICE OF DEFENSE TRANSPORTATION

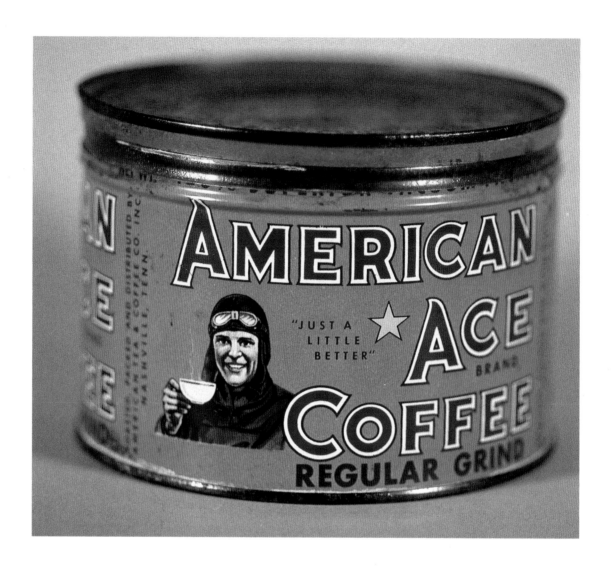

[ABOVE] *One-pound tin of American Ace Coffee,* American Teas & Coffee Co., Inc., Nashville, Tennessee.

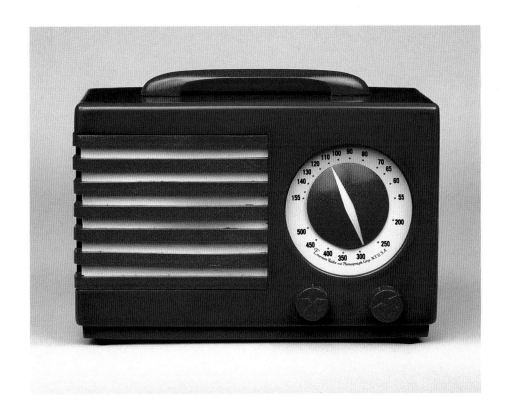

[LEFT] *The "Patriot" Monsanto plastic table-model radio,* produced by the Emerson Radio and Phonograph Company of New York in blue with red and white trim, was designed by Norman Bel Geddes in 1940. It sold for $15 and was also available in a red cabinet with blue trim.

[BELOW] *The "All American" Catalin radio,* produced in 1940 by the Fada Radio and Electric Company of Belleville, New Jersey. This classic "bullet" shaped streamliner "baby" radio in the aerodynamic rectangular teardrop style was produced to compete with the Emerson "Patriot."

(Both: Courtesy John Sideli, photos Michael Fredericks)

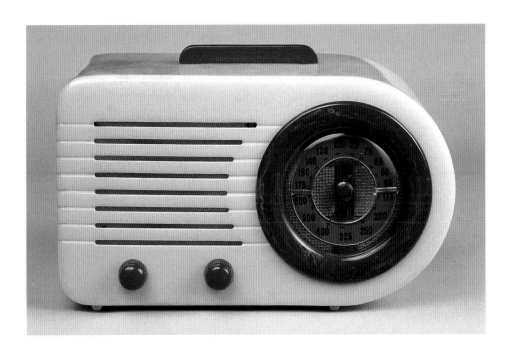

Home Sweet Home Front

MEMORY SNAPSHOTS

★ ★ ★

*T*HE KODAK "BROWNIE" AND other small portable box-like cameras faithfully recorded home front family portraits during World War II. Servicemen on leave posed happily with their wives and children, in romantic embraces with their sweethearts, or standing next to their families and good old neighborhood pals in a variety of assemblages. These cherished black-and-white photos would be kept in a uniformed man's wallet or sometimes posted on the wall of his barracks, to remind him of home and what it was he was fighting for. Likewise, the American family might receive in the mail a snapshot of a young soldier, sailor, or marine at camp or

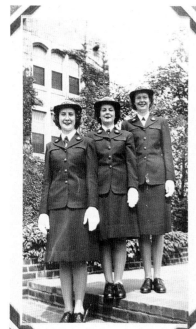

perhaps in an actual battle zone; if battle-zone photos were permitted to be sent home. A battle-zone snapshot might show a serviceman holding up an enemy flag after a victory or standing with a group of his buddies next to a war plane. Employers prohibited the taking of personal pictures at home front defense plants and discouraged it in other war-related workplaces for fear the images might fall into the hands of spies.

The snapshots that have survived this period are often fuzzy or muted due to the over exposure of the film, the simplicity of the camera, or the shaky hand of the anxious, good-intentioned amateur photographer. Despite their lack of clarity, these treasures would be carefully pasted with corner mounts into the black pages of an album and underneath the date and other information would be written in white ink.

[ABOVE] *Three U.S. Navy WAVES* in full dress uniform.

Servicemen and their families would also have a professional portrait taken at a neighborhood studio or in a city near boot or training camps, especially when a boy first donned his uniform. Sometimes these portraits would be color tinted and put into cardboard or reverse-painted-on-glass stand-up frames. At home·a stand-up portrait of a serviceman was always proudly displayed on top of a bureau, a bedroom vanity, a mantelpiece, or on the piano or console radio.

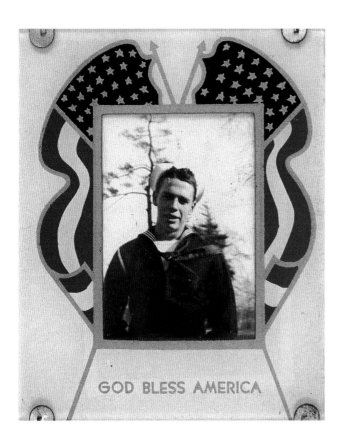

[LEFT] *"God Bless America"* reverse painted-on-glass frame with sailor snapshot.

[BELOW] *A soldier and his girl in saddleshoes.*

★ ★ ★

O N CHRISTMAS DAY, 1941, America had officially been a part of World War II for just eighteen days. Men and boys either joined the Navy or the Marines or were drafted into the Army and sent to training camps, ultimately to be shipped into active duty in the Pacific or to the front on the battlefields of Europe. Every man, woman, and child who was not in the service mobilized in a "Back the Attack" effort against the common enemy.

A year later, in December of 1942, people were lining up for ration stamps and a spiraling runaway inflation hit consumers with many food and product shortages. Buying bonds to help the government also lowered the family income; but still, at Christmas there was always some money set aside for family presents under a sparkling tree. One typical gift might be an envelope containing a gift War Bond which could be cashed in after the war.

The Christmases of 1941, 1942, 1943, and 1944 found many wives and children celebrating a wartime holiday with a husband overseas. Sons, brothers, and sweethearts sometimes had a

[ABOVE] *Christmas greeting card from the "Fighting First."*

Christmas leave; but more often these loved ones were fighting for their country and marking the holiday on foreign soil. When they did come home, you can be sure mother served up one of her special wartime cakes or pies. Christmas during World War II was usually a time of long-distance love, of loss, and of yearning. Bing Crosby's rendition of "White Christmas" played constantly on the radio or the plaintive "I'll Be Home For Christmas" ("if only in my dreams") had a special meaning to those in the service or those on the home front who stared sadly into colorful Mazda Christmas tree lights on a tree,

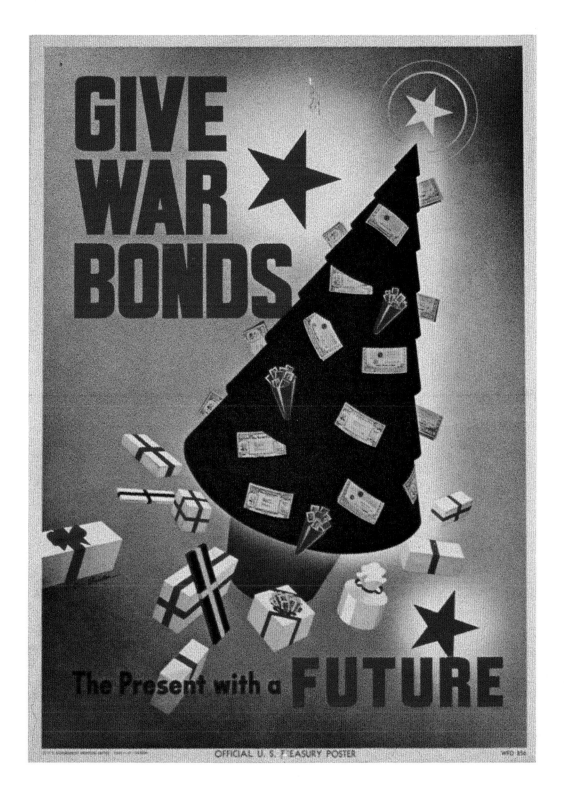

GIVE WAR BONDS

The Present with a FUTURE

OFFICIAL U. S. TREASURY POSTER

waiting and dreaming patiently for war's end. Christmas was never a time without deep sadness or battlefield tragedies; nevertheless on the American home front the Christmas season meant that an extra effort had to be made to spread a little cheer in keeping with the spirit of the season.

[LEFT] *"Give War Bonds"* with a Christmas Tree, official U.S. Treasury poster. (Chisholm Gallery)

★ ★ ★

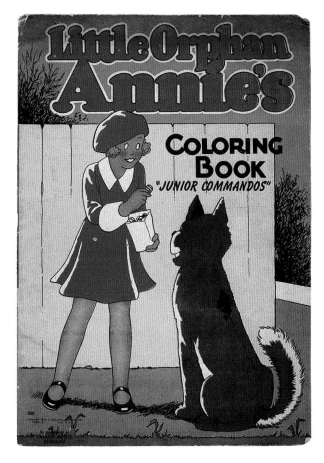

[ABOVE] *Little Orphan Annie "Junior Commandos"* coloring book, Saalfield Publishing Co., Akron, Ohio, 1942.

D URING THE WAR YEARS when boys and girls were not at school, doing homework, watching the movies, or doing their part for the war effort as members of the Junior Service Corps, the Junior Red Cross, or the Victory Corps, they might find some time to be just kids at play. After school some might rush home to listen to their favorite radio broadcasts, be it *The Lone Ranger, Jack Armstrong: The All-American Boy,* or *Captain Midnight.* During World War II, Harold Gray's comic character Little Orphan Annie, star of a radio program sponsored by Ovaltine from 1931 to 1940, launched her 1943 "Junior Commandos" through her popular comic strip. In Boston alone fifteen thousand children joined Annie's Junior Commandos popular outfit which instructed them in booklets to maintain an almost military discipline and attitude in their daily lives for the duration of the war. Home front jobs utilizing Annie's troops included selling war stamps and bonds, salvaging scrap, and collecting waste paper. Annie encouraged joining Civil Defense efforts and emphasized the "clean plate" campaign. The exploits and adventures of Little Orphan Annie's Junior Commandos who helped win the war were recounted in daily and Sunday newspaper comic strips, comic books, Big Little Books, and paint and coloring books.

Captain Midnight took over the radio from Little Orphan Annie in 1940. The Wander Company, makers of Ovaltine, decided that a man-in-action seemed more suitable for radio listeners in the forties than a little Depression-era orphan. *Captain Midnight* was broadcast on the Mutual Network from 1940 to 1949. Just like Little Orphan Annie's Commandos, Captain Midnight's *Secret Squadron* listeners were ordered to drink their Ovaltine out of a Beetleware shape-up mug. While Captain Midnight's cup was red and blue, Annie's had been a cream- and orange-colored mug. Both characters also had cups with Ovaltine messages printed on them: Captain Midnight's said, "Hot Ovaltine, the hearty breakfast!" while Little Orphan Annie's said, "Leapin' lizards, for a swell summer drink there's nothing like a cold shake-up, eh Sandy?" Annie's cartoon dog, Sandy, replied, "Arf!"

Hop Harrigan, a popular children's radio show with a war theme was first broadcast in 1942. *The Adventures of Superman,* sponsored by Kellogg's Pep cereal, came to the Mutual Network in 1940. *Terry and the Pirates,* and several aviation adventure series like *Sky King, Sky Blazers,* and the comic-strip character *Smilin' Jack,* who joined the Army Air Force when the war broke out, filled the airwaves as well as the Sunday comics.

In the comics, everyone went to war: Terry fought "Japs" instead of pirates and *Little Orphan Annie*'s Daddy Warbucks became a general. Joe Palooka, a Ham Fisher comic character, joined the Army as a private in 1940—boosting enlistment and receiving a personal thank-you from President Roosevelt. As exciting for kids, and often as up to the minute as the daily war headlines, were R. Sidney Bowen's war series published by Grosset & Dunlap. Stories narrating the electrifying adventures of Red Randall and his friend Jimmy Joyce, who were both boy fliers in Hawaii, appeared in *Red Randall at Pearl Harbor.* Lieutenants in the Army Air Corps shot down "Jap" zeroes in *Red Randall on Active Duty,* published in 1944. Bowen, who was a former R.A.F. flier, penned another true-to-fact war adventure series featuring seventeen-year-old American Dave Dawson and his sixteen-year-old English friend, Freddy Farmer. Titles included: *Dave Dawson at Dunkirk, Dave Dawson with the R.A.F., Dave Dawson with the Flying Tigers,* and *Dave Dawson with the Pacific Fleet.* Whitman Publishing Company of Racine, Wisconsin, issued a *Fighters for Freedom* series of stories for girls and boys during the war, including *Norma Kent of the WACS, Sally Scott of the WAVES, Sparky Ames and Mary Mason of the* Ferry Command, *and Barry Blake of the* Flying Fortress. Other popular titles in the

Whitman young reader series included *Smilin' Jack and the Daredevil Girl Pilot* based on the famous comic strip by Zack Mosley. A Captain Midnight adventure, *Joyce of the Secret Squadron,* was based on the popular radio program.

Children also enjoyed the Big Little Books and Better Little Books series also published by Whitman. These sturdy, thick little books with their colorful cardboard covers and hundreds of illustrations inside featured at-war characters from the comics, including Smilin' Jack, Buzz Sawyer, Little Orphan Annie and her Junior Commandos, Captain Easy, Don Winslow of the Navy, and Mac of the Marines. At the dimestore in the war years you could buy coloring books of these same comic characters for just ten cents. There were also paint and coloring books or paper doll cut-out books for boys and girls dedicated to different branches of the service.

Comic books which began to take over in popularity in the 1940s from Big Little Books depicted kids' favorite superheroes, such as Captain Marvel, Captain Marvel Junior, Mary Marvel, Superman, and Batman and his sidekick, Robin, fighting Hitler, Tojo, Hirohito, Mussolini, and other enemies of American freedom. During the war *All Star Comics,* a series begun in 1940, saw the origin of the Justice Society which included new superheroes like the Flash, the Spectre, Dr. Fate, the Green Lantern, the Hawkman, the Hour Man, the Sand Man, the Atom, and Johnny Thunder who joined forces together to fight against spies in America.

[RIGHT] *Collection of Big Little Books and Better Little Books* from the World War II period published by Whitman Publishing Company of Racine, Wisconsin. Top (left to right): "Smilin' Jack Speed Pilot", "Smilin' Jack and the Jungle Pipeline," "Smilin' Jack." Bottom (left to right): "Captain Easy Behind Enemy Lines," "Mac of the Marines in China," "Buz Sawyer and Bomber 13," "Don Winslow of the Navy versus the Scorpion Gang," "Punch Davis of the Aircraft Carrier."

Babes In Arms

DISNEY'S MICKEY MOUSE AND DONALD DUCK MARCH TO WAR

✫ ✫ ✫

*M*ICKEY MOUSE AND DONALD DUCK did their part in morale-building for all branches of the armed services by appearing as mascots on military insignia, patches, emblems, special signs, and flags. The first insignia emblem, created by Disney in 1940, pictured a venomous mosquito riding a Mosquito Fleet PT torpedo for the Motor Torpedo Boat Squadron in New York City. Twelve hundred unique insignia's were created free of charge during the war years by the Disney Studio, featuring most of the Disney characters and many new ones wielding machine-guns and throwing bombs. Donald Duck was more frequently used than Mickey Mouse, as he could readily express the necessary rage and anger the boyish, smiling Mickey could never quite muster up for the enemy. It is astonishing today to see a picture of Mickey Mouse sporting a childlike grin watching a Japanese ship sink, but he was depicted just this way for the entirety of the war.

The Disney Studio devoted ninety percent of its production during the war years to the output of films like *Food Will Win This War* and *Four Methods of Flush Riveting* made especially for the Navy, the Army, and for government agencies including the Treasury Department, the Department of Agriculture, and for the Office of the Coordinator for Inter-American Affairs. The Office of War Information's Bureau of Motion Pictures produced one of the most popular films made by Disney for the government, *The New Spirit* starring Donald Duck. The most commercially successful of all war cartoons and an Academy Award winner was *Der Fuehrer's Face* (1943), originally called *Donald Duck in Nutziland.* Inspired by the smash-hit song with humorous words and music by Oliver Wallace and recorded by Spike Jones and his City Slickers, the cartoon has Donald Duck ridiculing the very heart of fascism. Donald, attempting to decipher the gibberish of *Mein Kampf,* falls asleep and enters into a nightmare world in Nutziland watching a goose-step ballet. Hitler is the main scapegoat for the Duck's temper. Donald also hates the over-reg-

imentation and the lousy German food. Eventually waking up from the "Nazi" nightmare. Donald clutches a miniature of the Statue of Liberty and is glad to be free.

Donald Duck, Mickey Mouse, and other cartoon characters appear on home front bond rally posters and as emblems in defense factory programs. Along with Donald and Mickey, Bambi, José Carioca, Pinocchio, Goofy, Pluto, and more appeared on a special Disney U.S. Treasury Bond. Matchbooks, blotters, buttons, wall plaques and other items all included a go-to-war Disney character to help in the march toward victory in World War II.

[BELOW] *Mickey Mouse* marches to war on this cardboard "dimensional" coloring plaque made from a do-it-yourself kit: *"You color it, you mount it and you hang it yourself."* Youngstown Pressed Steel Company, unit of Mullins Manufacturing Corporation of Warren, Ohio, 1942.

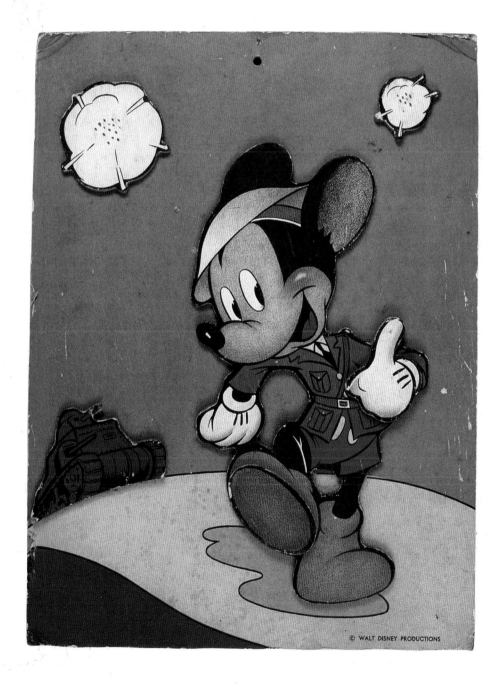

© WALT DISNEY PRODUCTIONS

Victory Glamour

VARGA GIRLS

★ ★ ★

*T*HE FIRST VARGA GIRL, an air-brushed artful all-in-color pin-up by artist Alberto Vargas appeared in *Esquire* magazine in October, 1940. Throughout the 1930s the Petty Girls, drawn by George Petty, were seen in the pages of *Esquire* and in cigarette and bathing suit ads. Until 1942, Petty and Varga girls, both possessing the same degree of "oomph," sex-appeal, and sophistication, competed for attention in *Esquire,* subtitled "The Magazine for Men," which sold for fifty cents. After 1942, the Petty Girl disappeared and the more realistic-looking Varga girls in sheer bathing suits, sarongs, hula skirts, and tight-fitted sweaters and shorts took over until 1946. During the war years these Varga girls often wore servicemen's hats, WAC accoutrements like a military hat or scarf, military insignia, or patriotic red, white, and blue attire. In December, 1940, *Esquire* received orders for more than three hundred thousand copies of the first complete *Varga Girl* calendar which sold for twenty-five cents. There were twelve pin-ups and a special four-line poem for each month; by 1943, one million orders were received for Varga's vastly popular calendar.

In the early 1940s the U.S. Post Office, in keeping with war regulations, revoked *Esquire*'s second-class mailing privileges, which were to be given only for literary, scientific, or artistic publications. The magazine went to court using testimony from psychiatrists, clergymen, professors, and public figures, and proved that the Varga Girl yearly calendars and the upscale ingredients of their magazine (the quality articles, the jokes, the mens' fashion spreads) were providing a service for the men of the United States armed forces. Indeed, the 8½"-x-11½" calendar was consid-

ered to be wholesome fun and in good taste, embodying an idealized vision of the all-American girls the G.I.s and the "Flyboys" had left behind. A Varga Girl calendar or a Varga Girl torn from the pages of *Esquire* decorated bombers, barracks, tanks, submarines, trucks, base hospitals, mess halls, and foot lockers. The Army Air Force took to copying their own primitive versions of the Varga Girl, painting a great many of them as "Nose-Art" on the front of their bombers and on the backs of A-1 leather flying jackets. One Air Force pilot jokingly complained to his unit that he couldn't figure out why one particular German plane kept circling dangerously around him until he realized that the German pilot was trying to get a better look at the pin-up mascot painted on the plane's nose.

Soldiers and civilians could also order a 4½"-x-7" set of six "Esky" Varga pin-up postcards for twenty-five cents and a deck of Varga Girl cellulose-coated moisture resistant "cleanable" playing cards for one dollar. It was the 1940s Varga Girl calendars, however, printed on heavy stock paper and bound with red plastic rings, that were saved by veterans and home front enthusiasts as precious mementos that helped get them through the war.

[LEFT] *Varga girl,* Western World Playing Card Company, St. Louis, Missouri.

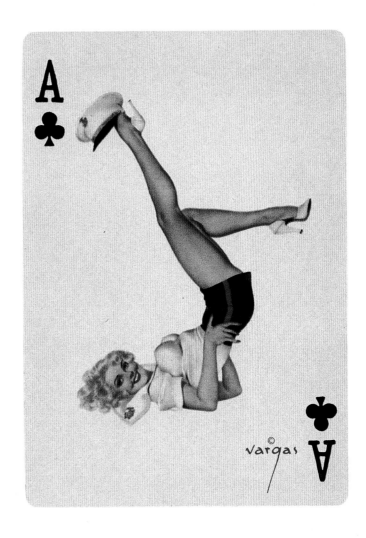

Victory Glamour

FORTIES FASHION VANITIES

★ ★ ★

[OPPOSITE] *Vogue magazine "United We Stand"* fashion issue, July 1, 1942.

Mᴏʀᴇ ᴛʜᴀɴ ᴀɴʏ ᴏᴛʜᴇʀ fashion designer, Adrian of M.G.M. Studios became responsible for the squared-off clumpy, almost-masculine military look in clothing for women in the 1940s. In the late thirties Adrian put Garbo, Crawford, and Shearer into outfits that sported peaked shoulders, but by the beginning of the war suits and dresses for women were all thickly padded at the shoulders. Hemlines were raised above the knee and high Cuban platform shoes, popularized by Brazilian bombshell Carmen Miranda, were the rage. The sleek, streamlined feminine look of the 1930s was out for the duration. Electro-permanent Marcel waves that created tight crimp curls and dips sculpted close to the head gave way to high upswept hairdos employing wire rollers or "rats" meant to build the hair up higher in the front, often into exaggerated pillars of rolled curls. Long thick hair was the vogue, ending in a page-boy undercurl or more clump curlets at the tips. Sometimes a gardenia, poppy, or an orchid would be clipped to one side of this built-up hairdo; with the pull-back upswept effect, ears were visible and large-sized bulbous earrings could be prominently displayed.

Veronica Lake, who became famous in films like *Sullivan's Travels, This Gun for Hire,* and *The Blue Dahlia* for her long silky blonde mane worn in a trademark "peek-a-boo" bang cascading easily and softly over one eye, was asked by the War Department to crop her hair into a short feathercut. She complied. This new shorter "permed" hairdo was meant to influence women who worked in the defense plants, many of whom were constantly getting their long hair caught and snarled in machinery. Lake's new tresses may have had an impact on women's fashion in war movies like *So Proudly We Hail,* but the public had difficulty accepting her without her famous bang. With her cut tresses, film magazines of the day reported her career took a decided nosedive. Lorraine Day and Claudette Colbert wore short feathercuts like the ones women were given when they joined the WACS or WAVES; but many women on the home front preferred to keep their

VOGUE

"United We Stand"

JULY 1, 1942 · PRICE 35 CENTS
40 CENTS IN CANADA

long hairdos with the high upswept fronts. Hairnets and kerchiefs became a fashion must, eliminating the hair hazard dilemma in the defense plant. Crochetted snoods like the ones Vivien Leigh (as Scarlet) and Olivia de Havilland (as Melanie) wore in the film *Gone with the Wind* enjoyed great popularity in the 1940s. During World War II there was a great deal of nostalgia for the Civil War period: the Southern-belle snoods quickly entered into the fashion marketplace. Women who took to wearing snoods were elated not to have to go to the beauty parlor to have their hair set in rollers or bobby pins as often.

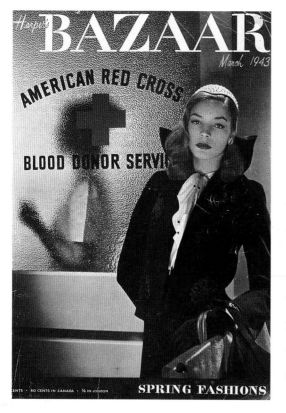

[ABOVE] *Harper's Bazaar magazine,* March, 1943. Spring Fashion issue, cover model Lauren Bacall.

Slacks and pants suits—the standard outfit worn by Katharine Hepburn in the 1930s and afterwards—became almost a defiant trademark for independent working women during the war years. Going to work at defense plants required heavy denim coveralls or slacks for women. These outfits spilled over into everyday life inspiring women to wear gabardine, corduroy, or woolen slacks in either slim cuts with no cuff or in fuller cuts with cuffs. Still, most women of the 1940s preferred to wear skirts or dresses; and many made their own outfits at home from *Vogue* or *Mademoiselle* patterns. The short coat took precedence over longer models, some hemmed just above the knee, while others ended just below the waist. A fox fur "chubby" coat could easily be worn over a padded shoulder suit.

Face make-up for women in the 1940s was meant to be "painted on" in an extreme manner. Prior to the forties only film or stage stars, sophisticated ladies, or wanton women went out into the streets with heavily made-up faces. Department store and dimestore cosmetic counters suddenly hired representatives from Dorothy Gray, Elizabeth Arden, Helena Rubinstein, Tangee, and Mabelline to teach women how to apply thick orange, tan, or tan-rose pancake make-up, red-creme rouge, blue, purple, or green eye shadow, black mascara, and pencil drawn eyebrows. Lipstick colors were called Victory Red, Patriot Red, or Scarlet and some had names like Orange Flame or Jungle Red. Black Raspberrys, Crimson Reds, or Fischias were also favorite colors for female lips. These thick lipsticks left their imprint everywhere, on coffee cups and men's shirt collars, as well. There was nothing dewy soft or feminine in the look for women of the 1940s. It seems that appearance had to have a hard edge. Women were becoming more independent and glamorous, perhaps in order to attract men, who were generally not available and a rare luxury in wartime.

In the popular war movie *Mrs. Miniver,* Greer Garson played a soft and ladylike character; however most American women chose to emulate Ida Lupino, Ann Sheridan, or Joan Crawford as *Mildred Pierce,* a fiercely independent character who baked pies for a living and rose to the top on "stink" and "grease." Bette Davis in *Now Voyager* had a great impact on women at "ladies" movie matinees in 1942–43. In the film, she goes from being a repressed old maid who wears only drab dresses and sensible shoes into a suddenly transformed, a la Max Factor, beauty with an upswept '40s hairdo, false eyelashes, and a red smear of a mouth painted squarely over the lipline. Expensive glittering gowns and dresses with padded shoulders and sequins help her win the love of a handsome and romantic shipboard passenger Paul Henried. American women were coming out of the proverbial homemaker closet wearing as much make-up as they pleased—and could—and lacquering their long fingernails Jungle Red, as well.

To add to this exaggerated "scarlet-woman" look, large colorful chunky Bakelite or Catalin jewelry was pinned onto jackets, coats, suits, or tailored outfits. Some of this jewelry if not clusters of red cherries or red hearts, might be patriotic "V" for Victory pins in red, white, and blue. There were also attractive war-theme celluloid dress-pins of comical soldiers, sailors, or marines and gold or silver "pin-on" bombers or ships. Colorful, carved Catalin bracelets worn by the dozen in a "Down Argentine Way" were all the rage. Tropical-Hawaiian and Brazilian patterns, bright colors, and gay accessories were the stuff of forties fashion. The style of dimestore chic was very much "in" for the duration.

[BELOW] *Advertisement* shows model sporting Elizabeth Arden's "Victory Red" lipstick.

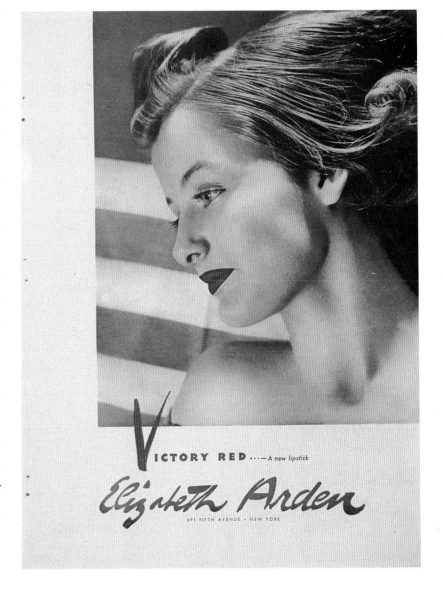

VICTORY RED····—*A new lipstick*

Elizabeth Arden

691 FIFTH AVENUE · NEW YORK

★ [93] ★

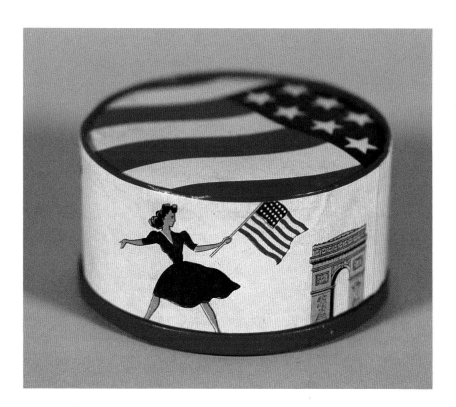

[ABOVE] *"Liberation of Paris" souvenir powder box* from Institut de Beaute, Paris, France, ca. 1944.

[RIGHT] *Gay Furlough Cologne,* bottle and box, distributed by Fabron, 225 Fifth Avenue, New York City.

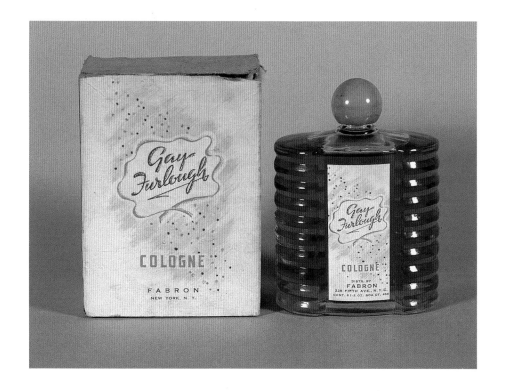

Hollywood Home Front

★ ★ ★

*O*N FEBRUARY 21, 1941, President Roosevelt addressed the 13th Annual Academy Awards via radio, reminding the film industry of its potential for solidifying the nation's resolve in support of a strong national defense. At that time movies had become the sixth-largest industry in the United States. With Hitler on his storm-trooper march in Europe throughout the 1930s, the feeling that war was in the air permeated Americans still in the grip of the Depression. With the prospect of entering the war hovering, Eddie Cantor answered the war-monger in song on his radio show in 1938:

> *"Let them keep it over there,*
>
> *With an ocean in between,*
>
> *Let us keep it clean—*
>
> *But some fools wanna fight."*

Sentiments in popular songs were blatantly patriotic. The Gene Krupa Orchestra offered "I Am An American," Dick Powell serenaded with the upbeat "He's My Uncle, Uncle Sam, I'm His Nephew!" and Vaughn Monroe sang "Is It Love Or Is It Conscription?" Musical films like *Born To Dance* (1936) with Eleanor Powell, Busby Berkeley's *Gold Diggers Of 1937*, featuring Joan Blondell singing "All's Fair in Love and War," and *Strike Up The Band* (1940) with Judy Garland and Mickey Rooney, all struck prewar militaristic notes.

After Pearl Harbor the Office of War Information (OWI) knew that Hollywood would serve a major part in the vital and necessary war propaganda effort. Leo Rosten, a deputy director of OWI said, "The singularly illuminating tools of the screen can be used to give the people a clear, continuous and comprehensible picture of the total pattern of total war." General Lewis Hershey allowed draft deferments for irreplaceable film workers. Major stars, directors, and writers were allowed to remain safely in Hollywood, though they were in effect conscripted as war workers and volunteers. Many of the popular Hollywood night spots and restaurants of the 1940s dimmed their lights and remained

MOVIE-RADIO GUIDE

TEN CENTS • CANADA—12c

PROGRAMS FOR JUNE 14—20

Exclusive!

Truth
About Stars
And the Draft

E87KC2D5V43

JIMMY STEWART
Read His Message to the Public

open only on weekends. Some of the organizations that the stars, who also doubled as air raid spotters and wardens, joined and worked in included the Volunteer Army Canteen Service, Bundles for Bluejackets, Aerial Nurse Corps, Women's Ambulance and Defense Corps, and the Civil Air Patrol. They also made movies, raised money at bond drives, and many entertained the troops in person at home and overseas.

The top stars of the years 1941 to 1945, according to *Life* magazine's tenth anniversary issue (November 1946) were:

	1941	1942	1943	1944	1945
1]	*Mickey Rooney*	*Abbott & Costello*	*Betty Grable*	*Bing Crosby*	*Bing Crosby*
2]	*Clark Gable*	*Clark Gable*	*Bob Hope*	*Gary Cooper*	*Van Johnson*
3]	*Abbott & Costello*	*Gary Cooper*	*Abbott & Costello*	*Bob Hope*	*Greer Garson*
4]	*Bob Hope*	*Mickey Rooney*	*Bing Crosby*	*Betty Grable*	*Betty Grable*
5]	*Spencer Tracy*	*Bob Hope*	*Gary Cooper*	*Spencer Tracy*	*Spencer Tracy*

Others in the top ten during the war years included Gene Autry, Bette Davis, Judy Garland, James Cagney, Roy Rogers, Humphrey Bogart, Cary Grant, and Margaret O'Brien.

The first Hollywood actor to go to war was David Niven, who returned to England in 1939 where he was commissioned a lieutenant in the British Navy. In 1943 he became a lieutenant colonel. Jimmy Stewart served in the U.S. Air Force and became a lieutenant colonel. In his flight squadron, Commander Stewart was responsible for ten planes and one hundred men. Flying a bomber named by the crew *Nine Yanks and a Jerk,* he went on to receive a Distinguished Flying Cross for his bravery and leadership abilities in the European theater of war. Clark Cable joined the Air Force as a private in 1942 following the death of his wife Carole Lombard in a plane crash. Rising to the rank of Major, Gable was as skilled at firing a machine gun on many missions over Europe as he was in handling a camera. Tyrone Power enlisted in the Marines in 1942 winning a commission and his pilot wings, later becoming a first lieutenant. Robert Montgomery, as a lieutenant commander in the U.S. Navy, saw action in the Atlantic, the Pacific, and the Mediterranean. He fought in the Kula Gulf Battle and commanded a destroyer during the invasion of France. Wayne Morris entered the Naval Reserve in 1942. He was commissioned a lieutenant in the Naval Air Command. Morris won the Distinguished Flying Cross in 1944 for destroying seven Japanese planes, six on the ground and one in the air. Henry Fonda entered the Navy in 1942 working his way up to lieutenant on staff duty, Air Combat. Sterling Hayden, after joining up with the Merchant Marines in 1941,

[OPPOSITE] *Movie-Radio Guide* featuring Jimmy Stewart, June 14-20, 1941.

transferred into the regular Marine Corps in 1942. Victor Mature joined the U.S. Coast Guard during the war and rose to the rank of chief boatswain's mate. Jackie Coogan, the ex–child star, won an air medal as a glider pilot with the Air Forces in Burma. Ronald Reagan became a lieutenant in the U.S. Army. Reagan acted in many servicemen's training films. Lew Ayers received honors for service in the Army Medical Corps in the Philippines.

Other Hollywood names who served in the Air Force were Gene Autry, Bruce Cabot, Alan Ladd, Burgess Meredith, Robert Cummings, and Robert Preston. John Huston, William Holden, Van Heflin, Mickey Rooney, Burt Lancaster, Robert Mitchum, and Desi Arnaz were in the army. The Navy got Robert Stack and Robert Taylor, the latter enlisting under his real name, Spangler Arlington Brugh.

[BELOW] *Movie star Gene Tierney* selling War Bond stamps, cover of *Movie-Radio Guide*, November 1–7, 1941.

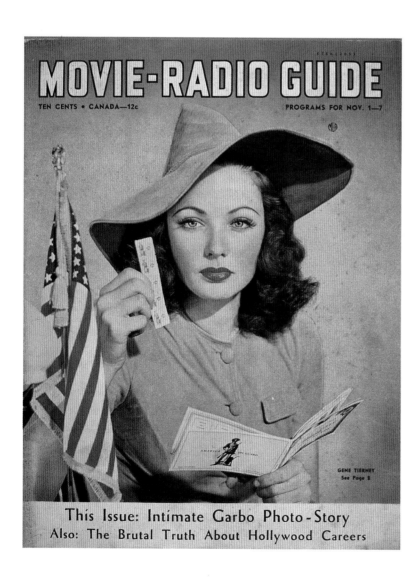

Hollywood Home Front

★ ★ ★

BETTE DAVIS AND JOHN GARFIELD conceived of the idea for a Hollywood Canteen for servicemen. Garfield, who had been classified 4-F by the Selective Service, felt it was the least he could do for the war effort. Davis became president of the Hollywood Canteen Foundation with Garfield always on hand to help out in any capacity. Once the money was raised, and with the help of studio carpenters, technicians, and forty-two unions (all of whom donated their services) the Canteen opened at 1451 Cahuenga Boulevard near Sunset Boulevard on October 17, 1942. The Canteen welcomed all servicemen in uniform from the United Nations Armed Forces. A veritable nightclub was constructed out of what was once just an old barn. The Canteen attracted Hollywood's most glamorous stars who washed dishes, served crullers and coffee, and enjoyed doing a fox-trot or a jitterbug with one of Uncle Sam's boys.

In an interview at the Canteen, published in *Colliers Magazine* in January 1943, Bette Davis had this to say about the servicemen's center she championed:

> "The Hollywood Canteen was created with one idea in mind—
> to give men in the armed forces some fun and a chance to meet
> personally the people of the entertainment world in Hollywood.
> We can always tell when a boy has seen actual battle. They have
> something in their eyes. There was a marine here last night who
> said to me, 'You'll never know what it means to see girls and
> hear music. Just let me sit please.' There are a few accomplish-
> ments in my life that I am sincerely proud of. The Hollywood
> Canteen is one of them."

A serviceman might find himself eating a donut, drinking coffee, and chatting or dancing with (among others) Deanna Durbin, Rita Hayworth, Barbara Stanwyck, Dorothy Lamour, Claudette Colbert, Betty Grable, or Bette Davis herself, who occasion- ally got up and sang with Kay Kayser's or Harry James's Orchestra. Usually the

bandsinger was someone like Ginny Simms, Dinah Shore, Judy Garland, or Peggy Lee. One Christmas eve Bing Crosby came with his three young sons to sing Christmas carols to servicemen. Marlene Dietrich baked three thousand cakes in a week. Roddy McDowell fondly remembers working there as a busboy. Masters of Ceremonies included Eddie Cantor, Basil Rathbone, and Fred MacMurray. Anyone who was anybody might turn up to participate in the festivities. All in all, there were twenty five hundred men every night at the Hollywood Canteen, five-hundred entering at a time. It was estimated that over three million servicemen were served at the Canteen during the war. Though operating expenses were three thousand dollars per week, nobody was charged a penny and the Canteen never solicited donations. The focus was to keep the boys happy and give them a little bit of home away from home.

The millionth G.I. to enter the Canteen was Sergeant Carl Boll. The lucky Yank got to spend four days basking in the company of stars. This event was the basis for the Warner Brothers movie called *Hollywood Canteen,* released on December 13, 1944. Robert Hutton played the role of the lucky soldier in the film and Dane Clark was his sidekick buddy. Joan Leslie, as herself, was the canteen-girl love interest for Hutton. Roy Rogers sang the Cole Porter song "Don't Fence Me In" while Trigger danced on his hind legs. The Andrews Sisters did a rousing reprise of the same song which they later recorded (with

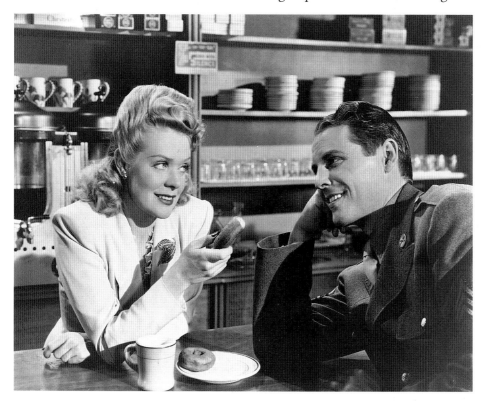

Bing Crosby). This recording went on to be a smash hit on jukeboxes and on the radio in 1944–45. Jimmy Dorsey's and Carmen Cavallero's orchestras provided the music in the film.

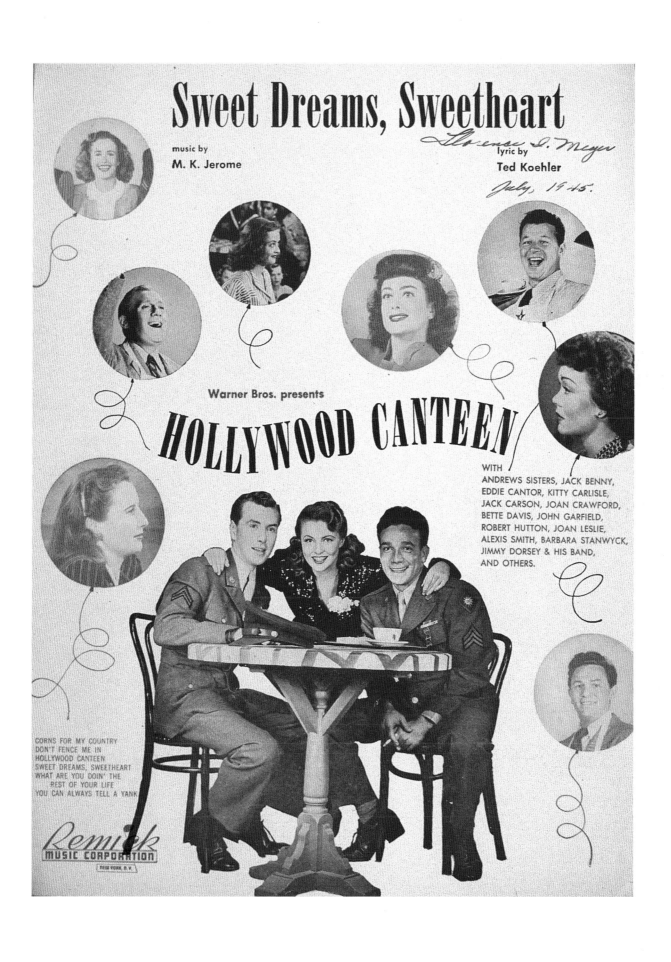

★ ★ ★

[BELOW] *Movie theater window card* for the 20th Century Fox film *Pin-Up Girl* with Betty Grable, John Harvey, Martha Raye, Joe E. Brown, Eugene Pallette, and the Charlie Spivak Orchestra, litho on cardboard, 1944.

*T*HE BACK-SHOT, LOOKING-over-the-shoulder photo of movie-star Betty Grable with her upswept hairdo, skintight bathing suit, and high-heeled satin pumps became the number one pin-up for servicemen of World War II. Grable's famous million-dollar legs, greatly admired by servicemen in all the armed service branches, were insured with Lloyd's of London by her studio, 20th-Century Fox, for one-and-a-half million dollars. A pin-up of Betty Grable was used as a grid to teach combat recruits map reading. Wartime aviators painted a pin-up likeness of the Betty over-the-shoulder pose on the nosefront of their bomber-fighter planes. The idea of a special fantasy pin-up girl like Betty helped the G.I.s fighting morale; magazines like *Yank* and *Army Weekly* took note, running a pin-up photo of some Hollywood star in every issue.

Betty Grable, called "The Technicolor Blonde," with her bleached platinum locks, lush red lips, baby-blue eyes, and curvaceous figure also had the personality that registered with servicemen and the public alike during the war years. She seemed to combine mother, sister, and sweetheart all at once; her singing manner projected both a sultriness and a great warmth that reached into everyone's heart. Her genuine beguiling smile captivated audiences and helped lift their spirits out of the

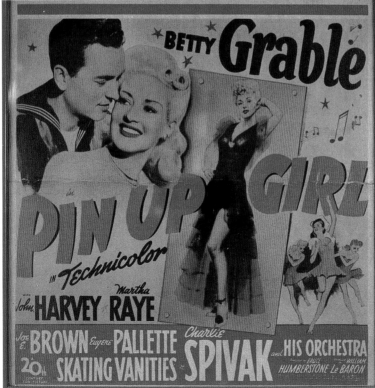

anxieties of wartime. She was number eight on the list of top-ten movie stars in 1942, jumping to number one by 1943, remaining in the top four in both 1944 and 1945, and in the top-ten list through 1951. When Betty offered to fox-trot with servicemen in a "tag dance" on the opening night of the Hollywood Canteen she had to change partners forty-six times. In a poll of flyers in 1943, Betty became "the girl we'd like to fly with in a plane on automatic pilot."

In the midst of the war, and at the height of her popularity, Grable married tall, dark, and handsome bandleader Harry James on July 5, 1943, at the Last Frontier Hotel. Together these two appeared on band tours, mail-call broadcasts, and at bond rallies for the war effort. At one war bond drive they both attended in Long Beach, California, Betty offered a pair of her nylon hosiery to members of the huge crowd: they sold for forty thousand dollars. She and husband Harry coaxed another three million dollars out of the pockets of patriotic citizens on that same day.

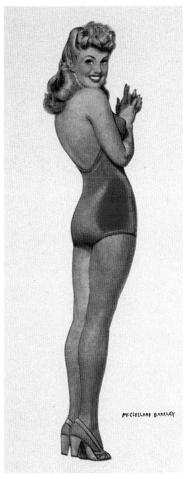

Second in popularity to the Betty back-shot pin-up was a photo of Rita Hayworth provocatively kneeling on a bed and wearing a slinky black lace and satin nightgown. Red-haired Rita was chosen by Army flyers in World War II to be "the woman we would most like to be cast adrift with." Others who were popular World War II pin-ups included sarong-girl Dorothy Lamour and sweater girls Paulette Goddard and Lana Turner. Another was Jane "The Outlaw" Russell, then a protegé of the mysterious millionaire Howard Hughes. She was selected to be mascot of an Air Force Squadron called "Russell's Raiders."

At one point Postmaster General Frank C. Walker ordered that the Grable pin-up not be sent through the U.S. mails for "obscenity reasons." This caused a ruckus in the press and only increased the demands from servicemen for a copy of the "notorious" photo. Some conservatives objected to what they called Betty's "come hither" look. By 1944 there were plenty of pin-ups in circulation anyway.

[LEFT] *Betty Grable* by McClelland Barclay from a 5" x 8" pin-up collection given away at the Roxie Theater in New York for the Betty Grable movie *Footlight Serenade*, 1942.

Hollywood Home Front

LET'S GO TO THE MOVIES

✱ ✱ ✱

The following is a selected list of Hollywood films
with home front or battlefield themes made from 1941 through 1946:

1941

YANK IN THE R.A.F., 20th Century Fox: The sky battles and air combat scenes were such thrilling entertainment that some citizens labeled the picture a war-mongering epic. It stars Betty Grable and Tyrone Power as the "Yank."

DIVE BOMBER, Warner Brothers: Starring Errol Flynn, Fred MacMurray, Alexis Smith, Allen Jenkins, and Regis Toomey. An air fighter epic.

SERGEANT YORK, Warner Brothers: Gary Cooper won an Academy Award for his performance as a gentle hillbilly farmer who becomes a hero of World War I.

I WANTED WINGS, Paramount: Starring William Holden, Ray Milland, Wayne Morris, and Brian Donlevy, as B-17 pilots and Veronica Lake as the girl mascot.

1942

THE FLEET'S IN, Paramount: One of the most entertaining musicals of the war era starring Dorothy Lamour and Betty Hutton as girl singers who entertain the fleet in San Francisco and fall in love with two sailors played by William Holden and Eddie Bracken. Big band music is provided by Jimmy Dorsey and his Orchestra with vocals by Helen O'Connell and Bob Eberle. Although the plot is just a romantic mix-up, the music and jitterbugging are top-notch wartime entertainment.

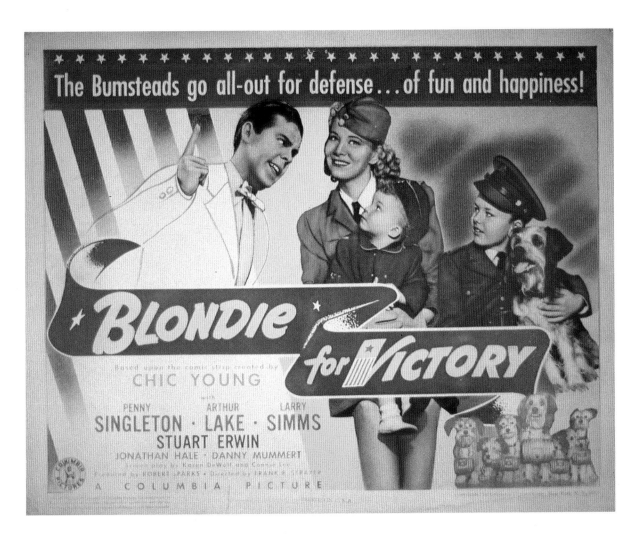

The Bumsteads go all-out for defense...of fun and happiness!

BLONDIE for VICTORY

Based upon the comic strip created by
CHIC YOUNG

with

PENNY
SINGLETON · LAKE · SIMMS
ARTHUR LARRY
STUART ERWIN
JONATHAN HALE · DANNY MUMMERT

A COLUMBIA PICTURE

HOLIDAY INN, Paramount: Bing Crosby, Fred Astaire, and Marjorie Reynolds star in this simple story about a quaint country inn where Bing produces musical extravaganza's only on holidays. The film introduced "White Christmas," sung by Bing Crosby, and called the quintessential wartime song every homesick G.I. could identify with.

FOR ME AND MY GAL, M.G.M.: A World War I story directed by Busby Berkeley and featuring Judy Garland, Gene Kelly, and George Murphy revives the hits from that era including: "How You Gonna Keep 'em Down on the Farm, After They've Seen Berlin?" and "What Are You Going to do to Help the Boys?"

FLYING TIGERS, Republic: Set in China where the AVG (American Volunteers Group) are outnumbered by Japanese aircraft and featuring John Wayne, John Carroll, Paul Kelly, and Tom Neal.

TO BE OR NOT TO BE, Drama, romantic comedy, suspense, and farce are wittily com-

[ABOVE]
"The Bumsteads go all-out for defense . . . of fun and happiness" in *Blondie for Victory*, with Arthur Lake, Penny Singleton, Larry Sims, and Daisy the Dog. Columbia Pictures series, 1942, lobby card.

bined by Ernst Lubitsch. Jack Benny impersonates Hitler and stars with Carole Lombard, in her last picture before her fatal crash.

YANKEE DOODLE DANDY, Warner Brothers: Jimmy Cagney stars as George M. Cohen, the flagwaving patriotic showman who sent audiences straight out of the theater to sign up for battle with songs like "Over There," "Yankee Doodle Dandy," and "You're a Grand Old Flag."

MRS. MINIVER, M.G.M.: Hailed as a great war film that dealt with inner meaning rather than outward realities of war, it swept the Academy Awards winning seven, including Best Picture. Greer Garson (Best Actress), Walter Pidgeon, Helmut Dantine, and Teresa Wright (Best Supporting Actress) were featured.

CASABLANCA, Warner Brothers: Paul Henried, Ingrid Bergman, Claude Rains, Conrad Veidt, Humphrey Bogart, and Helmut Dantine star in the famed film which was the keystone for the "Bogie cult" and revived the song "As Time Goes By." This film is regarded by many as the best of all the films of the war era.

IN WHICH WE SERVE: Directed by David Lean, co-directed by and starring Noël Coward, it depicts the story of a British destroyer and its crew, based on the career of Lord Louis Mountbatten.

1943

SWING SHIFT MAISIE, M.G.M. series: Aircraft assembly-line workers Maisie (Ann Sothern) and her rival (Jean Rogers) battle for the love of James Craig, a company test pilot.

THANK YOUR LUCKY STARS, Warner Brothers: All-star musical cavalcade with Eddie Cantor, Humphrey Bogart, Errol Flynn, Joan Leslie, Ida Lupino, Dinah Shore, and Bette Davis singing "They're Either Too Young or Too Old," a song that complains about the man shortage on the home front.

THE GANG'S ALL HERE, 20th Century Fox: Directed and choreographed by Busby Berkeley (his first film in Technicolor), this home front musical features Alice Faye as a U.S.O. canteen girl who sings "A Journey to a Star" directly to her boyfriend James Ellison on the Staten Island Ferry. The Harry Warren songs are played by Benny

Goodman and his Band and Carmen Miranda sings "The Lady in the Tutti-Frutti Hat" in a choreographed number that has been called Berkeley's best.

A GUY NAMED JOE, M.G.M.: A romance set in wartime Pacific where a P-38 pilot competes with the ghost of a dead flyer (played by Spencer Tracy) for the love of a WASP flyer played by Irene Dunne.

HITLER'S CHILDREN, R.K.O.: This film about Hitler's indoctrination of German youth into the National Socialist Party shocked Americans; it featured Bonita Granville, Kent Smith, and Tim Holt.

AIR FORCE, Warner Brothers: This World War II action film directed by Howard Hawks features Gig Young and John Garfield as crew members on a B-17 caught up in the opening moments of the fighting in the Pacific, Hawaii, Wake Island, and the Battle of the Coral Sea.

SO PROUDLY WE HAIL, Paramount: The story of combat nurses adapted from first-hand accounts of the Philippine-Japanese offensive, with Claudette Colbert, Paulette Goddard, Veronica Lake, Sonny Tufts, and George Reeve.

1944

LIFEBOAT, 20th Century Fox: Based on a story by John Steinbeck about the occupants of a lifeboat drifting in the Atlantic, with Tallulah Bankhead, William Bendix, John Hodiak, and Hume Cronyn.

THE FIGHTING SULLIVANS: The true story of five brothers who all died together on the American cruiser U.S.S. *Juneau* in the South Pacific. Anne Baxter stars and Selena Royale and Thomas Mitchell play the parents.

SEE HERE PRIVATE HARGROVE, M.G.M.: Robert Walker and Donna Reed star in this adaptation from a popular wartime book by G.I. Marion Hargrove providing amusing details of Army camp life.

STAR-SPANGLED RHYTHM: Betty Hutton sings "I'm Doing it for Defense," with Marjorie Reynolds, Betty Rhodes, and Donna Drake in this all-star Paramount Revue.

ROSIE THE RIVETER: The female defense worker Rosalind "Rosie" Warren (Jane Frazee) delays marriage to work in the aircraft industry. Rosie and Vera are shunned by the working men at first but as they become more skilled the women are treated as equals.

PIN-UP GIRL, 20th Century Fox: Betty Grable and Martha Raye star in a Technicolor musical entangled with servicemen, featuring the Charlie Spivak Orchestra.

[ABOVE] *A scene from the home front movie* David O. Selznick's *Since You Went Away* with, left to right, Shirley Temple, Jennifer Jones, and Claudette Colbert.

UP IN ARMS: Dinah Shore stars as a WAC Lieutenant with Danny Kaye as a private who is smitten and dominated by the lady.

GOING MY WAY, Paramount: Bing Crosby plays a priest and Rise Stevens is an opera star in a New York slum story with Bing singing "Swinging on a Star." The film won "Best Picture, at the Academy Awards.

MEET ME IN ST. LOUIS, M.G.M.: A romantic musical stressing family life with Judy Garland, Margaret O'Brien, Tom Drake, Mary Astor, and Lucille Bremmer; the song "Have Yourself a Merry Little Christmas" had strong emotional meaning to servicemen and home front civilians.

SINCE YOU WENT AWAY: David O. Selznick directs this treatment of an American home front civilian family and the difficulties encountered by the inhabitants of "that fortress, the American home." Claudette Colbert played the mother, Shirley Temple and Jennifer Jones the daughters, and Hattie McDaniels as the maid. The men were played by Joseph Cotten, Monty Wooley, Robert Walker, and Guy Madison.

THIRTY SECOND OVER TOKYO, M.G.M.: Van Johnson, Robert Walker, Robert Mitchum, Spencer Tracy, and others are the Doolittle Raiders who flew bombers over Tokyo in retaliation for Pearl Harbor and were forced to crash in enemy territory for lack of fuel.

WINGED VICTORY, 20th Century Fox: From the Broadway play by Moss Hart, Darryl Zanuck's tribute to the Army Air Corps pilot-training program, with Lon McCallister and Jeanne Crain.

THE MEMPHIS BELLE, Paramount: A documentary by William Wyler filmed with the real U.S.A.A.F. crew showing the final and twenty-fifth mission over Germany in June 1943 using the B-17 Memphis Belle Bomb Group. The film contains aerial operation and ground footage in color.

1945

GOD IS MY CO-PILOT, Warner Brothers: From a best-selling book by Colonel Robert Lee Scott who became a hero with General Claire Chenault's "Flying Tigers."

KEEP YOUR POWDER DRY, M.G.M.: Three girls from different backgrounds join the Women's Army Corps, featuring Lana Turner, Lorraine Day, and Susan Peters.

THEY WERE EXPENDABLE: Director John Ford's epic tale of a PT boat squadron in the Philippines, outnumbered and outgunned, with John Wayne, Robert Montgomery, and Ward Bond.

1946

THE BEST YEARS OF OUR LIVES, RKO: Top post-war film of homeward bound G.I.'s, featuring Myrna Loy, Frederick March, Virginia Mayo, Dana Andrews, Teresa Wright, Steve Cochran, and Gladys George. Academy Awards included Best Picture, Best Actor (March), Best Director (William Wyler), Best Screenplay (Robert E. Sherwood), and Best Supporting Actor (Harold Russell), who received an additional award for "bringing hope and courage to his fellow veterans." Russell had both hands amputated in the war and became an actor in this film in order to show some of the dilemmas a returning vet must face without the full use of his arms.

★ ★ ★

ONE OF THE GREAT wartime hits at the Broadway Theater in New York, the National Theater in Washington, D.C., and on tour across the country was *This Is the Army,* a musical revue produced at the request of the Army Emergency Relief Fund, and presented by Uncle Sam, with songs by Irving Berlin, that featured a company of three

hundred soldiers. *This Is the Army* eventually played overseas in London, Algiers, Italy, Egypt, Iran, India, British New Guinea, the Philippines, and the Marianas, closing in Honolulu on October 22, 1945. When it opened in 1942 (July 4) for a limited run of twelve weeks, it was destined to be a sellout. Berlin, who had written the first all-Army show—*Yip, Yip Yaphank*—in 1918 for World War I once again wrote new inspired songs for *This Is the Army.* It included "Oh, How I Hate to Get Up In the Morning" from the first World War show, sung in both shows by Irving Berlin himself. Other songs in the show included: "This is the Army, Mr. Jones," "I Left My Heart at the Stage Door Canteen," "The Army's Made a Man Out of Me," and "With My Head in the Clouds." Soon after the Broadway engagement Warner Brothers made a film version of the show starring Ronald Reagan.

Joan Leslie was Reagan's girl-next-door sweetheart and Kate Smith was added to sing "God Bless America." For his work on *This Is the Army,* and for writing "God Bless America" (which many during World War II regarded as a second national anthem), Irving Berlin was awarded the Medal of Freedom, America's highest civilian honor. Decades later, President Ronald Reagan awarded the Medal of Freedom to Kate Smith for her part in the World War II effort.

Among other hit Broadway shows in the 1942 and 1943 height-of-the-war season were: *Winged Victory* by Moss Hart; *Stars and Garters* co-starring Bobby Clark and Gypsy Rose Lee; *Porgy and Bess* with music by George Gershwin; *Good Night Ladies By Jupiter* starring Ray Bolger; *Without Love* starring Katharine Hepburn; *Life With Father,* then in its fourth year; *My Sister Eileen* with Shirley Booth as older sister Ruth; and *The Three Sisters,* Chekov's drama directed by Guthrie McClintock starring Katharine Cornell, Judith Anderson, and Ruth Gordon.

[OPPOSITE] *Souvenir book,* limited first edition, for Irving Berlin's "All Soldier" show *This Is the Army,* illustration by Corporal Dave Breger.

[BELOW] *"I Left My Heart at the Stage Door Canteen,"* hit song from *This Is the Army* by Irving Berlin, Kenny Baker vocal, orchestra directed by Harry Sosnik, 78 rpm Decca record.

★ ★ ★

[ABOVE] *"(We'll Be Singing Hallelujah) Marching Through Berlin"* from the movie *Stage Door Canteen,* sung by Miss Ethel Merman, RCA 78 rpm record in original paper sleeve.

ON THE EAST COAST in New York the Stage Door Canteen opened its doors to servicemen on March 2, 1942, in the 44th Street Theater. The American Theater Wing, which began as a war service organization on December 15, 1941, just after Pearl Harbor, was the sponsor. Following the New York lead other Stage Door Canteen branches opened in Washington, D.C., Philadelphia, San Francisco, New Jersey, and Massachusetts. There were also branches founded in England and Australia. Broadway entertainment, coordinated by co-chairwomen Radie Harris and Betty Lawford in New York City was provided from 3:30 P.M. until midnight by stars like Gertrude Lawrence, Helen Hayes, Katharine Cornell, and Tallulah Bankhead. Radio personalities like Bea Wain would also drop by and Eddie Cantor was a frequent visitor there. Hollywood stars like Bette Davis, Alice Faye, or Marlene Dietrich would pitch in when they were in town and Broadway notables would do the same for the Hollywood Canteen when they traveled west. Eleanor Roosevelt often stopped by at the Stage Door, as did the Duchess of Windsor who enjoyed a twirl on the dance floor with a soldier.

The word around town in 1943 was that this was the "in" place to have a good time and civilians (only four allowed per night) paid one hundred dollars just to watch the proceedings from the balcony. In its first year it was estimated that seven hundred and twenty thousand men passed through the doors of New York's famous Stage Door Canteen. Brooks Atkinson, the *New York Times* drama critic said, "It seemed as if it had been there always." The war, it was said, created a true democratic classless society in the

canteens and at U.S.O. shows around the world. All soldiers of the United Nations were welcome at the canteens and English R.A.F. flyers mingled with Chinese air pilots, Dutch sailors, Russian naval officers, Canadians, Indians, and African-Americans serving in the military.

Stars seemed to enjoy washing dishes, doing odd chores, cooking, or making sandwiches. Schraft's restaurants provided thirty-six hundred homemade-style "Victory Doughnuts" every night which were referred to by servicemen as "B-sinkers" when they were dunked in a cup of coffee. There were special Thanksgiving Day, Christmas, and New Year's feasts supplied to the canteen by top restaurants. One New York Thanksgiving gala turkey dinner for four thousand men was prepared, carved, and served by leading chefs of the day. Each soldier and sailor received a special box of servicemen's greeting cards to send to sweethearts, mothers, wives, and other beloved relatives and pals. On a good night the Stage Door Canteen served two thousand sandwiches and poured out three thousand cups of coffee.

An all-star movie version called *Stage Door Canteen* was made by United Artists in 1943 starring Cheryl Walker and William Terry. There are a great many parallels between the plots of *Hollywood Canteen* and *Stage Door Canteen*. Ethel Merman does an upbeat war song called "Marching Through Berlin" in this film and additional musical entertainment features Benny Goodman with vocalist Peggy Lee, Xavier Cugat with Lina Romay, Count Basie with Ethel Waters, Guy Lombardo with Rosemarie Lombardo and the orchestras of Freddy Martin and Kay Kayser.

[BELOW] *Souvenir movie program* for the picture *Stage Door Canteen*, 1943.

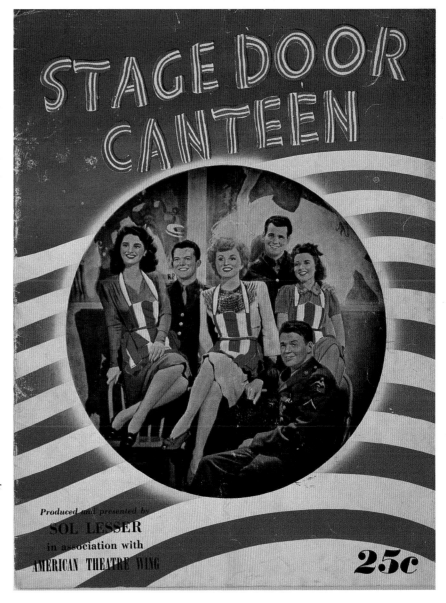

★ ★ ★

*T*HE UNITED SERVICE ORGANIZATION for National Defense, later shortened to U.S.O., was established as a governmental agency on February 4, 1941 and had the full support of the War and Navy Departments. The federal government donated fifteen million dollars to help support the organization before America entered the war and close to that amount was raised from private and public contributions. Initially six civilian organizations formed the U.S.O.: the YMCA, the YWCA, the Salvation Army, the National Catholic Community Service, and the National Jewish Welfare Board. These groups met as representatives of the U.S.O. to coax other patriotic groups like the Elks, the Moose Club, and the American Legion to do their part for servicemen.

[ABOVE] *Pinback button* from United Service Organizations, the U.S.O.

When U.S. troops grew from fifty thousand in 1940 to twelve million by 1944, the U.S.O. servicemen's clubs created a home away from home in over three thousand communities, some near military camps and others in major cities. At U.S.O. drop-in clubs hostesses who were nice young ladies, housewives, or mothers doing their part for the war effort served milk, hot coffee, and doughnuts. Here soldiers could play cards or read a magazine or book at their leisure. The U.S.O. Victory Campaign (with the American Library Association) gathered thirteen million books and three million magazines for this purpose, as well as for shipping to camps or to overseas stations. Legend has it that the famous graffiti statement "Kilroy Was Here," coined during World War II, was written on a bathroom wall at a U.S.O. club. It came literally to mean: "A serviceman—a soldier, a sailor, a marine—was here!" Sometimes a "Kilroy" image, a bald-headed comic character with a "schnozzola" nose peering over a fence, would accompany the notification that the mysterious "Kilroy" had been there.

In addition to running the service clubs, the U.S.O. had many activities. It operated a "rest and recreation" haven at the Royal Hawaiian Hotel on Waikiki Beach for

battle-fatigued submarine sailor crews and aviators returning from or enroute to highly dangerous missions in the Pacific. The U.S.O. also organized what was often referred to as the "Foxhole Circuit": fifty-nine national touring companies and two hundred and twenty-eight companies overseas featured celebrities, music, and entertainment.

From 1941 to 1947 over two hundred million people saw over four hundred thousand performances filled with Hollywood and Broadway stars on far away makeshift stages, on ships, and often at remote front lines or in hot jungle camps. Some of the most memorable shows included those led by Bob Hope, who often brought along singer Frances Langford, comic Jerry Colona, or sarong girl "Dottie" Lamour. Stan Laurel and Oliver Hardy toured many Caribbean bases; Ingrid Bergman sang Swedish folksongs in 1943 on a tour by boat and by plane to Alaska and the Aleutians; Al Jolson performed in places like Sicily, Alaska, England, and the Caribbean; and Jack Benny toured tirelessly with shows in the South Pacific (the "Sarong Circuit") and North Africa. Ann Sheridan did an eight-week stint in Burma and other nearby island bases while Dinah Shore toured in England and France singing sad songs like "The Last Time I Saw Paris" to boys who cheered her on.

The dynamic duo of Fred Astaire and Bing Crosby did the U.S.O. "Foxhole Circuit" in Europe. Bing was dubbed "Der Bingle" by the Nazis and he frequently joined in on shows organized by his "road" film nemesis, Bob Hope. They were greeted with roars of appreciative G.I. laughter as they hurled insult upon insult at one another. Stars of the U.S.O. entertainment show included Marlene Dietrich, who was on Hitler's death list but chose to ignore it, the Andrews Sisters, and Hattie MacDaniels, the beloved "Mammy" from *Gone With The Wind.* Joe E. Brown was the servicemen's favorite from Chungking and New Guinea to Naples and Nome, Alaska. For the men he typified the dauntless spirited role Hollywood played in World War II.

Another U.S.O. group tour featured Carole Landis, Martha Raye, Mitzi Mayfair, and Kay Francis. Famed war correspondent Ernie Pyle singled them out for their amazing adaptability and courage in going to out of the way places to entertain "the boys." Just to get overseas, according to the popular book *Four Jills and a Jeep,* written by Carole Landis, they first flew to the Bahamas, then to the Azores, then to Ireland and finally on to England where they met the Queen. Pyle said these gals deserved medals for their five-month army camp tour of Europe and North Africa, in which they traveled 37,000 miles. Carole dedicated the story of the real life adventures of Martha, Kay, Mitzi, and herself, which was later made into a movie starring the four actresses, "to officers and enlisted men who made our tour so inspirational."

★ ★ ★

*T*HE TOP COMPOSERS OF Tin Pan Alley answered the call to war with popular songs geared to inspire men to join in the battle. Listening to the voices of Marlene Dietrich or Hildegarde singing "Lili Marlene" or Bing Crosby softly crooning, "White Christmas" on a record player or over the radio could bring forth in a serviceman yearnings of home and a sense of hope and idealism. Loneliness, love, and separation has always

been the stuff popular song writers churned out; but during the war these themes took on a special meaning for those who went to war and the ones they left behind on the home front. Sometimes just a song title can evoke a powerful wartime nostalgia for those who remember a special romantic moment like the return of a loved one, or of one who was lost to the war.

During the war it was reported that sales of wedding rings jumped 300 percent just four months after Pearl Harbor. Many couples became engaged while at a U.S.O. dance or while listening to favorite songs played by a live orchestra or on a Wurlitzer jukebox. When a serviceman reported for duty and left a sweetheart, fiancée, or new warbride behind there were always songs playing on the radio that gave them comfort. Actor Jason Robards Jr., who was in the Navy at Pearl Harbor, remembers World War II as "the war that was heard on the radio airwaves . . ." and that included the voices, the big bands, and all those wonderful songs.

On the home front and in military camps the popular music of World War II became the channel through which powerful emotions and sentiments could be expressed, either to help bolster the fight against the enemy or to express the loneliness of those left behind. One song, "The White Cliffs of Dover," promised that bluebirds would one day come back to England's beautifully scenic and serene cliffs following the war—and that little "Johnny" could once again be safe in his own little bed; but only when peace returned. Militaristic "March-to-War" patriotic songs like "Remember Pearl Harbor" or "Praise the Lord and Pass the Ammunition" appealed directly to the heart of the fighting spirit.

While romantic songs of the 1930s Depression era focused on a new and happy world on the other side of the rainbow, on honeymoon cottages, or on money miraculously falling out of the sky, the love songs of World War II spoke of loss and loneliness. Tearful odes like "I'll Walk Alone," "I'll Be Seeing You," and "I'm a Little on the Lonely Side Tonight" replaced earlier images of couples spooning under the starlight or a silvery moon. The 1940s girlfriend at home simply waited and pined just as her soldier-boy did at camp or on a break during combat on the field of battle.

The titles of songs collected from sheet music of the World War II era, from 78 rpm record bins in antique shops, and from 1940s wartime song hit and *Hit Parader* magazines tell the story in themselves. These are selectively listed below according to their particular sentiment, impact, and popularity during World War II.

[ABOVE] *"Bell Bottom Trousers"* sheet music published by Santly-Joy, Inc., New York, 1943.

[OPPOSITE] *"G.I. Jive"* sheet music, Capitol Songs, Inc., New York, 1943.

Patriotic—The "Wake Up and Go To Battle" songs:

"Remember Pearl Harbor"

"Praise the Lord and Pass the Ammunition"

"Shout! Wherever You May Be—I Am An American"

"Let's Go U.S.A.! Keep 'em Flying"

"God Bless America"

"Victory Polka"

"Let's Bring New Glory to Old Glory"

"When We Plant Old Glory in Berlin"

"Lonely" Home Front Songs

"I'm Glad I Waited For You"

"It's Been a Long, Long Time"

"You'll Never Know (Just How Much I Miss You)"

"Sentimental Journey"

"I Don't Want to Walk Without You"

"I'll Be Seeing You"

"I'll Walk Alone"

"We'll Meet Again (Don't Know Where, Don't Know When)"

"A Nightingale Sang in Berkeley Square"

"When the Lights Go On Again (All Over the World)"

"Till the End of Time"

"Dream (When You're Feelin' Blue)"

"Lili Marlene"

"You'd Be So Nice to Come Home To"

Songs that Helped Get the Job Done

"I'm Doin' It For Defense"

"On the Swing Shift"

"Rosie the Riveter (B-r-r-r-r-r! B-r-r-r-r-r!)"

"Cooperate with Your Air Raid Warden (Siren Sam your Air Raid Man)"

"There Will Be No Blackout on Democracy"

"Harvey the Victory Garden Man"

"Scrap Your Fat"

"There's A Blue Star Shining Bright in a Window Tonight"

"Any Bonds Today?"

"Cash for Your Trash"

Songs About Soldiers, Sailors, Marines, and Air Force Flyers

"You Can't Say No to a Soldier"

"Boogie-Woogie Bugle Boy (of Company B)"

"Comin' in on a Wing and a Prayer"

"He's A-1 in the Army (and He's A-1 in My Heart)"

"He Wears a Pair of Silver Wings"

"Dear Mom (I'm Homesick for You)"

"Send a Salami to Your Boy in the Army"

"What Does a Soldier Dream Of?"

"I Left My Heart at the Stage Door Canteen"

"Bell Bottom Trousers (Coat of Navy Blue)"

"My Bomber and I"

"Johnny Zero"

"With My Head in the Clouds"

"G.I. Jive"

"Goodbye Mama (I'm Off to Yokohama)"

"Hubba-Hubba-Hubba (Dig You Later)"

"I Wanna Marry a Bombardier"

[ABOVE] *"Comin' In On a Wing and a Prayer"* sheet music, Robbins Music Corp., 1943.

Humorous "Get the Enemy" Songs

"Blitzkrieg Baby"

"Der Fuehrer's Face"

"Judgement Day's A-Comin' (For that Schickelgruber Man)"

"Let's Put the Axe to the Axis"

"You're a Sap, Mr. Jap"

"(We're Gonna Hang Out) The Washing on the Siegfried Line"

"The Jap and the Wop and the Hun"

"Don't Let's Be Beastly (to the Germans)"

"(There'll Be A) Hot Time in the Town of Berlin (When the Yanks Go Marching In)"

"Keep 'em Smiling (Show the Hun the Rising Sun)"

Home Front Christmas Songs

"I'll Be Home for Christmas (If Only in My Dreams)"

"(I'm Dreaming of a) White Christmas"

"Jingle Bells" (Glenn Miller's wartime version)

"Have Yourself a Merry Little Christmas

(Next Year All Our Troubles Will Be Out of Sight)"

The Music of World War II

GLENN MILLER

★ ★ ★

*O*F ALL THE BIG BANDS of the war years, none other came to represent the sound of a period and of a time more than the Glenn Miller Orchestra. Born Alton Glenn Miller in Clarinda, Iowa, on March 1, 1904, Glenn Miller began playing the trombone in a variety of orchestras like Red Nichols and Ben Pollack and His Californians in the mid 1920s, soon afterward developing skills as an arranger. By the early 1930s he put together a band in New York City and did musical arrangements for the Dorsey Brothers Orchestra. He also created arrangements for Ozzie Nelson and Glen Gray. Miller played with the Ray Noble and Vincent Lopez Orchestras in the mid 1930s putting together his own band in 1937 with the money he had saved. This orchestra had no distinct style of its own. It was not until one year later that he organized another band in which he developed the unique sound we now associate with Glenn Miller. The five-reed orchestrations consisted of a clarinet and tenor saxophone playing the melody an octave apart with the other three reed instruments harmoniously moving alongside and in between. The new Glenn Miller Orchestra rose quickly to the top of the charts with recordings and personal appearances: by 1939 it was one of the most popular bands in America.

Every Tuesday, Wednesday, and Thursday at 7:15 P.M. from December 27, 1939 on, America's radio listeners could tune in to hear fifteen minutes of music by Glenn Miller and his Orchestra, sponsored by Chesterfield Cigarettes. Liggett and Myers, makers of Chesterfield, initially felt the orchestra could not sustain the time slot on its own and brought in the Andrews Sisters; but when the popular sister act left, the orchestra did just fine all by itself. Paul Douglas, who later became a movie actor, was the show's announcer; and the vocalist members of the band included Marion Hutton (sister of Betty Hutton), Ray Eberle, Tex Beneke, and the Modernaires. The memorable broadcasts lasted until September 24, 1942. It was in that summer of '42 that Miller attempted to enlist

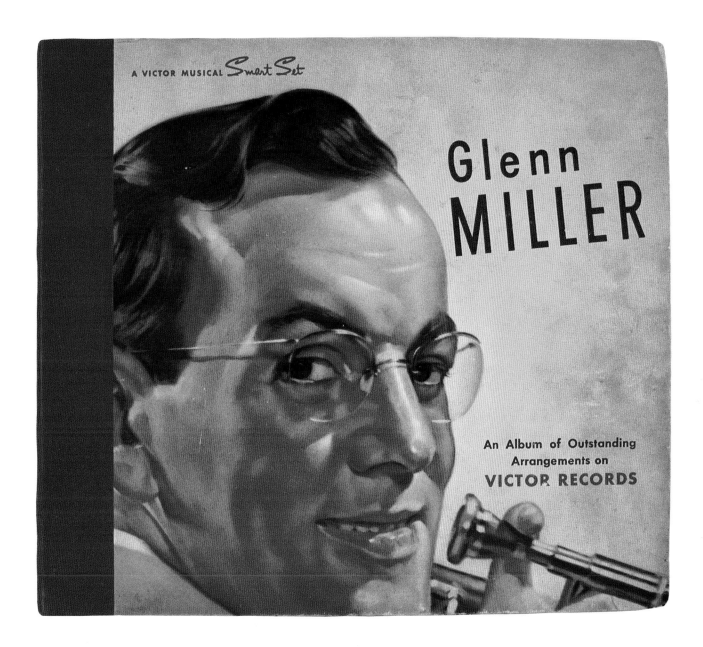

A VICTOR MUSICAL *Smart Set*

Glenn MILLER

An Album of Outstanding
Arrangements on
VICTOR RECORDS

his entire orchestra as an entertainment unit into the U.S. Navy, but the Navy was not interested. Up to that point the now famous dance band had played sold out dates at the Meadowbrook in Cedar Grove, New Jersey, and at the prestigious Glen Island Casino on Long Island. The orchestra also played at many War Bond Rallies and entertained the troops at camps. From March through May 1941 the Glen Miller Orchestra worked in the 20th Century Fox film *Sun Valley Serenade* starring blonde Norwegian Gold Medal Olympic champion ice-skater Sonja Henie, and also featured Lynn Bari and John Payne. The memorable songs from this winter wonderland musical romp included "I Know Why," "It Happened in Sun Valley," "Sun Valley Jump," and an extended version of the hit song, "Chattanooga Choo Choo."

[ABOVE] *Glenn Miller*
78 rpm record album containing eight selections,
RCA Victor.

Movie audiences got a second chance to view and listen to the Glenn Miller Orchestra in the 1942 film *Orchestra Wives*. With the war now in full swing the movie was filled with patriotic references and a few of the songs included wartime messages. "American Patrol," written by Jerry Gray, was a jitterbug upbeat go-to-war instrumental while "Moonlight Sonata" gave Beethoven a run for his money, adding a low-key Big Band arrangement to the classical composition.

Following this film and his failed attempt to enlist the band with the U.S. Navy, Miller offered his services to the Army. The Army said yes to his plan to form a musical unit to entertain the troops and he joined up on October 7, 1942. Band members who did not join for various reasons said a sad farewell admist tears and hugs when Glenn Miller disbanded the civilian orchestra. As Army Captain Alton Glenn Miller, he put together the 418th A.A.F. Band which initially played at Yale University in New Haven, Connecticut. In July of 1943 Miller's Army Air Force Band played on a show called "I Sustain the Wings," broadcast coast to coast. A great morale booster for the war effort, this unit played at War Bond Rallies, raising huge amounts of revenue for the government. Captain Glenn Miller, who became Major Glenn Miller, longed to entertain fighting troops and when D-Day came, General Dwight D. Eisenhower sent him a telegram inviting the Army Air Force Band to come to England to entertain the G.I.s. *The Big Band Special* with Major Miller at the helm, performed at hundreds of British theaters, halls, and military bases over a six-month period. By the end of 1944, Miller, with France just liberated, wanted to get closer to the fighting troops stationed on the continent. In a short period of time the A.E.F. Band (Allied Expeditionary Forces) tirelessly pre-recorded eighty-three radio broadcasts to be sent to troops all over Europe while maintaining their other performance schedule at the same time. On December 15, 1944, Major Glenn Miller, with another officer and pilot, took off in a small single-engine Norseman plane for Paris to make preparations for his A.E.F. Victory Orchestra tour. Three days later, members of the band arrived in Paris only to hear that Miller's plane was missing. An official Air Force intelligence inquiry concluded that the small plane went down somewhere in the English Channel. No trace of the aircraft has ever been found; the mystery surrounding Miller's disappearance has only added to his legend.

In 1955 a movie called *The Glenn Miller Story* was made about Miller and his beloved wife Helen starring Jimmy Stewart as Glenn and June Alyson as Helen. The film was a chronicle of the history of the band, its music and their enduring relationship. Immensely popular, *The Glenn Miller Story* revived the interest in Glenn Miller's music for generations that followed.

Some of the more unusual war-theme songs that the Glenn Miller Army Air

Force Band entertained servicemen with included "Enlisted Men's Mess," "Flying Home," "Tail End Charlie," "Mission to Moscow," "St. Louis Blues March," and "Jeep Jockey Jump." In 1942 the Glenn Miller civilian orchestra recordings on the Bluebird label contributed to the wartime effort at home and overseas.

In the popular home front song "The Five O'Clock Whistle (never blew)," "Daddy" makes up an excuse for returning home late and missing supper, telling an outraged "Mama" that the five o'clock factory whistle never blew. "Jukebox Saturday Night" was a hit with the bobbysoxers who jitterbugged frantically to the lyrics:

"Moppin' up soda pop Rickies,

To our heart's delight,

Dancin' to swingaroo quickies,

Jukebox Saturday night."

This song helped the jukebox industry, which grew during the war years into an eighty million dollar business reaping the profit of five billion nickels poured into four hundred thousand jukeboxes yearly.

In 1974 Bing Crosby, talking about the 1940s Big Bands, Benny Goodman, Henry James, Woody Herman, Jimmy Dorsey, Charlie Spivak, Claude Thornhill, Kay Kayser, Glen Gray's Casa Loma Orchestra, Artie Shaw, and others, said, "They were all great, but I have to say the Glenn Miller Band was the greatest!" Hearing the music today, it is as alive and fresh as ever—and still—the best.

The Hits of Glenn Miller

"Keep 'Em Flying"

"Dear Mom"

"Don't Sit Under the Apple Tree (with anyone else but me)"

"When Johnny Comes Marching Home"

"Soldier, Let Me Read Your Letter"

"On the Old Assembly Line"

"She'll Always Remember"

"Conchita, Marquita, Lolita, Pepita, Rosita, Jaunita Lopez"

"Knit One, Purl Two"

"(There'll be Blue Birds Over) The White Cliffs of Dover"

"It Happened in Hawaii"

"My Prayer"

"The Five O'Clock Whistle (never blew)"

"Skylark"

"In The Mood"

"Pennsylvania Six-Five Thousand"

"Tuxedo Junction"

"Little Brown Jug"

"Sunrise Serenade"

"Moonlight Cocktail"

"Moonlight Serenade"

"Perfidia"

"The Lamplighter's Serenade"

"Sweet Eloise"

"Elmer's Tune"

"A String of Pearls"

★ ★ ★

THREE SISTERS WHO SANG their songs into the hearts of millions of Americans and who were regarded as home front national treasures were Patty, Maxene, and Laverne Andrews—better known to most folks as "The Andrews Sisters." Almost like living embodiments of Rosie the Riveters, these right-up-front gals with their beaming show-business smiles were real "jumpin'-jive-jitterbugs" who sang "The Boogie Woogie Bugle Boy of Company B." Not to mention they could also be counted on to cut a mean rug. At other times the sisters could dreamily sway to and fro in perfect harmony, singing songs like "I'll Be With You in Apple Blossom Time." One of their top wartime songs was "Don't Sit Under the Apple Tree (With Anyone Else But Me)."

Among many other '40s hits, their version of "Any Bonds Today?" sold countless bonds at rallies during the war years. Their 78 rpm Decca record-platters, which sold in the millions, were played everywhere, on jukeboxes, at soda shops, or on phonographs at U.S.O. servicemen's centers. They performed regularly at canteens, on radio programs that were sent overseas on V-discs, and joined in on many U.S.O. tours. They appeared together in Hollywood wartime films like *Buck Privates* (with Abbott and Costello) wearing WAC uniforms and in *Private Buckaroo, Swingtime Johnny, Her Lucky Night,* and *Hollywood Canteen.* Patty, the aggressive push-punch-and-pull lead singer stood out and was always sandwiched in the center between the other two. She was the sultry blonde one, while Maxene and Laverne, both with brown hair, were more or less her sidekicks. "We look like the Ritz Brothers in drag!" Patty once remarked.

[ABOVE] *"(There'll Be a) Hot Time in the Town of Berlin (When the Yanks Go Marching In),"* Bing Crosby and the Andrews Sisters with Vic Schoen and his orchestra, 78 rpm Decca record.

[OPPOSITE] *"Don't Sit Under the Apple Tree— (With Anyone Else But Me),"* in photo left to right: Maxene, Patty, and Laverne Andrews, sheet music Robbins Music Corp., New York, 1942.

The Andrews Sisters came to represent the new tough spirit of women on the march in the '40s with their upswept hairdos, padded shoulders, and overly cosmeticized faces. Compared to the southern feminine charms of the Boswell Sisters whose soft sweet voices had dominated the '30s, these brash and hard-as-nails women basked in the spotlight the 40s decade beamed onto them.

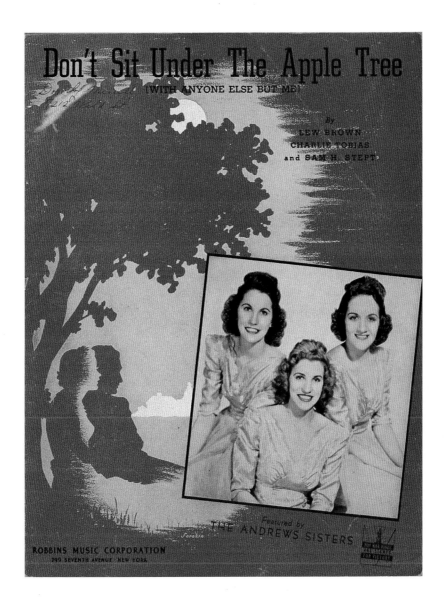

The Music of World War II

KATE SMITH

★ ★ ★

During the war years Kate Smith came to symbolize "The American Mom" to many on the home front and foreign battlefronts. Large, robust, commanding, and possessing a folksy maternal forthright charm, Smith seemed to embrace everyone in the free world. Singing Irving Berlin's "God Bless America," Smith inspired Americans to go forth and win the war and buy more bonds. Kate herself sold six hundred million dollars worth of War Bonds and raised four million dollars for the Red Cross. A radio marathon (eighteen hours on a live mike) on September 21, 1943, had listeners calling in their pledges of thirty-nine million dollars worth of bonds and stamps.

The rousing, patriotic song "God Bless America" was first broadcast over the air on "The Kate Smith Hour," a CBS Network show on November 10, 1938. Irving Berlin was backstage at this broadcast and called "God Bless America" his proudest effort. Afterwards on the radio and at War Bond Rallies and U.S.O shows, Kate Smith sang the song over and over again: it became the anthem of World War II. Franklin Roosevelt presented Kate Smith to the Queen of England, telling her Royal Majesty, "This *is* America!" President Truman cited her for the Legion of Honor; and in the 1980s she was awarded the Medal of Freedom by President Reagan.

Originally from Greenville, Virginia, Kate Smith was discovered in 1926 performing in a Washington D.C. vaudeville house by a Broadway producer who immediately put her into a show in New York. Two other Broadway shows followed, one opposite Bert Lahr, which garnered some name recognition for the chubby girl who had a voice of pure gold. During this time she met impresario Ted Collins, an executive at Columbia Records who gave her a recording contract and became her personal manager. They had only a verbal contract splitting the fees on a fifty-fifty basis and this sense of trust continued for thirty years. Though they never married, Ted and Kate were referred to by friends as "love-

birds" due to the strong devotion they had for one another. In May of 1931 Ted Collins arranged for "The Songbird of the South," as she had come to be known, to have her first fifteen-minute show, four times a week on CBS. Though she had to brave it on the air opposite "Amos 'n Andy," the most popular show on radio at that time, she kept her place with her great booming voice, her sincerity, and her unique way with a song. Smith made an impression on movie-goers in the Burns and Allen–Bing Crosby Paramount film *Big Broadcast of 1932* which also featured, in a revue format, the Mills Brothers, the Boswell Sisters, and the Cab Calloway Orchestra. Kate Smith sang the plaintive song "It Was So Beautiful" in this film. By 1943 Kate was broadcasting a show three times a week, which always opened with her theme song "When the Moon Comes Over the Mountain," and was hosting a weekly variety program called *The Kate Smith Hour,* which could be heard on the radio Thursday nights at 8 P.M. In the 1940s, the years in which she reigned supreme, Smith received over three million fan letters a year.

On one of her afternoon daytime shows for women, sponsored by Swan's Down Cake Flour and Calumet Baking Powder, Kate Smith loved to give home front houswives her recipes for her big-sized double-layer cakes, birthday cakes, chocolate fudge cakes, wartime cakes and quick breads, biscuits, rolls, muffins, and cookies. Cakes, covered with thick rich frosting, and Kate Smith seemed to go hand in hand; everyone craved a home-baked sugar-filled dessert in wartime. Millions of mothers and housewives followed Kate Smith's recipe for "Victory Doughnuts" during World War II, often bringing a batch of them to their local U.S.O. center. Nothing reminded a serviceman more of home than a freshly made doughnut and a cup of steaming hot perked coffee.

Kate Smith's Home-Style Wartime "Victory Doughnut" Recipe

2 ½ cups sifted cake flour
2 teaspoons baking powder
½ teaspoon salt
¼ teaspoon nutmeg
2 eggs or 4 egg yolks, well beaten
½ cup sugar
½ cup heavy cream

Sift flour once, measure, add baking poweder, salt and nutmeg. Beat eggs until thick, adding sugar. Add flour, alternating with cream, a small portion of each at a time, beating after each addition until smooth. Turn out on well-floured board and knead lightly thirty seconds. Roll to ¼" thick; cut with floured 1 ¾" doughnut center. Fry in deep fat (370°F.) until crullers turn rich brown color, turning frequently. Drain on paper towels or a clean brown paper bag. Cool, and then sprinkle with confectioners sugar. Makes thirty Victory Doughnuts.

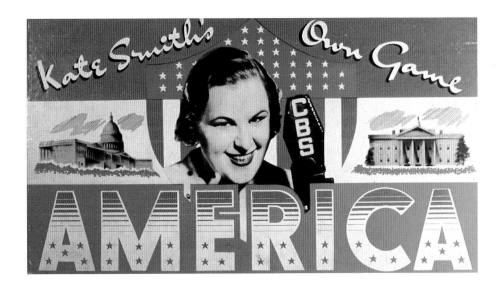

[LEFT] *Kate Smith designed "America,"* her own game manufactured by Toy Creations, Inc., New York, 1941.

★ ★ ★

MADISON AVENUE HUCKSTERS WHO developed advertising campaigns to help sell commercial products during the war worked overtime to make a "patriotic" connection between their client's need to sell their goods or services and the popular war effort. Automotive and other manufacturing companies that phased into the business of tanks, trucks, or planes took out full-page color ads in top national magazines depicting their retooling into the machinery of war. "Keep 'Em Flying," "Keep 'Em Rolling" slogans wound up in ads; but so did others like "Keep 'Em Pretty" which showed a model sporting red Dura-gloss polish on her nails as she pastes another Minuteman stamp in her U.S. Savings Bond book.

One of the most successful ad campaigns of the war in 1942 was "Lucky Strike *Green* has gone to War," in which the American Tobacco Company changed their packages from green to white. The idea was that the solid dark-green ink used in the package printing contained bronze which was diverted to build tanks. True or not, sales of Luckies zoomed upward by 38

percent after the redesign by Raymond Loewy. The ads also said servicemen and those on the home front smoked to "curb anxiety."

Johnny Roventini was the tiny Hotel New Yorker bellboy who became the spokesman for Phillip Morris cigarettes. Yelling out "Call for-r-r Phillip Mor-r-r-e-e-s!", the tiny rosy-cheeked living trademark symbol passed out samples to servicemen at U.S.O. centers and at the Stage Door Canteen. On the radio, 1940s Big Bands were sponsored by cigarette companies. There was "The Camel Caravan" with the Benny Goodman Orchestra which employed the phrase "I'd Walk a Mile for a Camel." Chesterfield Cigarettes sponsored Glenn Miller; Raleigh and Kool Cigarettes presented Tommy Dorsey; Old Gold had Artie Shaw; and Lucky Strike backed Kay Kayser and *The Hit Parade*. Likewise, movie stars like Betty Grable, Claudette Colbert, Joan Bennett, Maureen O'Hara, and others posed in ads, smiling, with a Chesterfield dangling from their red lips.

The Coca-Cola Company advertising campaigns commissioned magnificent paintings showing rosy-cheeked smiling defense plant workers, servicemen in canteens, and troops around the world drinking a bottle of Coke. These ads and cardboard signs helped promote confidence in the average consumer who subliminally felt they were participating in the war effort when they drank a Coca-Cola. Manufacturers of other popular soft drinks like Pepsi Cola, Royal Crown Cola, and Mission Orange Soda employed similar ads. Orders of the Coca-Cola Company executives during the war were "to see that every man in uniform gets a bottle of Coca-Cola for five cents, wherever he is and whatever it costs the company." Five billion bottles of Coke were consumed by military service personnel during the war, in addition to countless servings from dispensers and mobile, self-contained units in battle areas.

It was "smart" to chew gum in the 1940s, and Wrigley's and other gum companies recommended the chewing of gum "to help calm down those war nerves." Another ad might show a "Johnny Zero" air pilot taking a bite out of a Milky Way candy bar—for energy—before jumping into the cockpit of his plane. American businesses wanted to win the war and the only way to succeed was to join in. Many product ads also included the

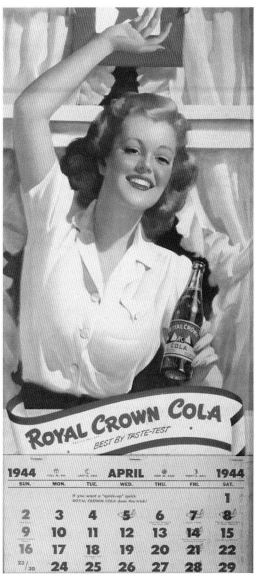

[ABOVE] *1944 calendar* from Royal Crown Cola.

[OPPOSITE] *Trommer's Malt Beer* die-cut display cardboard sign showing a defense plant worker on her lunch break.

ubiquitous "Buy War Bonds and Stamps" appeal. Matchbook graphics also went to war functioning almost as mini-posters where "V for Victory," "Remember Pearl Harbor," or "Keep 'Em Flying" was the order of the day—in miniature.

Clearly, advertisers were either enlisted by government agencies or felt it was their patriotic duty to present ads that were connected to the military or the home front defense effort. From today's vantage point, the ads in magazines, posters, or billboards did help lead the way to victory—and to sell that product in wartime.

[RIGHT] *"Millions working for Victory"—Wrigley's Spearmint Gum* litho-on-cardboard insert poster for trains and buses.

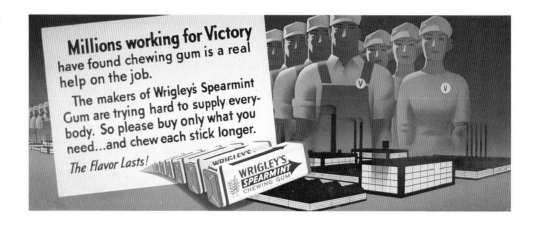

★ ★ ★

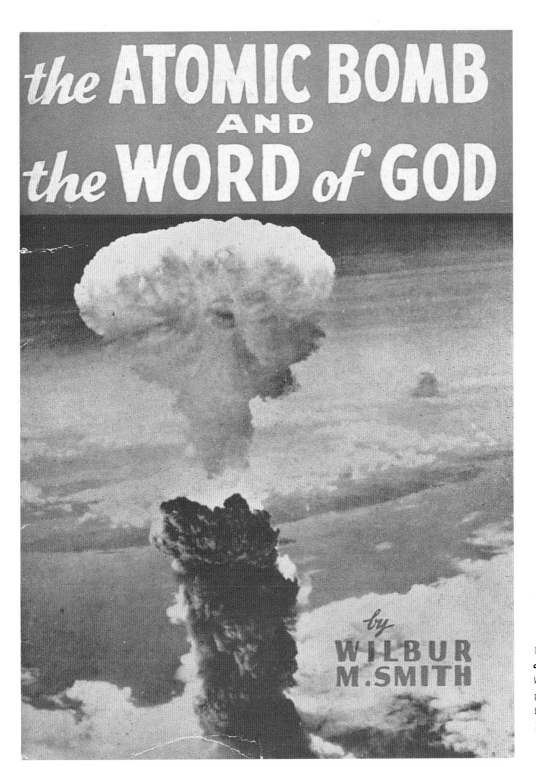

[LEFT] *The Atomic Bomb and the Word of God* by Wilbur M. Smith, pamphlet published in 1945, by the Moody Bible Institute, Chicago.

Selected Bibliography

★ ★ ★

Berube, Allan, *Coming Out Under Fire,* The Free Press, New York, 1990.

Black, Gregory D., and Clayton R. Koppes, *Hollywood Goes to War,* Free Press, New York, 1987.

Boehm, Edward, *Behind Enemy Lines,* Wellfleet Press, Secaucus, New Jersey, 1989.

Brown, DeSoto, *Aloha Waikiki,* Editions Limited, Honolulu, Hawaii, 1985.

————, *Hawaii Recalls,* Editions Limited, Honolulu, Hawaii, 1982.

————, *Hawaii Goes to War,* Editions Limited, Honolulu, Hawaii, 1989.

Buxton, Frank, and Bill Owen, *The Big Broadcast,* Avon Books, New York, 1973.

Casdorph, Paul D., *Let the Good Times Roll,* Paragon House, New York, 1989.

Clawson, Augusta H., *Shipyard Diary of a Woman Welder,* Penguin Books, New York, 1944.

Cohen, Stan, *V for Victory,* Pictorial Histories Publishing Co., Missoula, Montana, 1991.

Collins, Philip, *Radios,* Chronicle Books, San Francisco, 1987.

Ethell, Jeffrey L., and Clarence Simonsen, *The History of Aircraft Nose Art,* Motorbooks International, Osceola, Wisconsin, 1991.

Fraser, James, *The American Billboard,* Harry N. Abrams, Inc., New York, 1991.

Geddes, Donald Porter, (Editor), *Franklin Delano Roosevelt,* Dial Press, New York, 1945.

Gilles, Lhote, *Cowboys of the Sky,* Avirex Ltd., Long Island City, New York, 1988.

Gil-Montero, Martha, *Brazilian Bombshell,* Donald I. Fine, Inc., New York, 1989.

Harris, Mark Jonathan, Franklin Mitchell, and Steven Schechter, *The Homefront: America During World War II,* G. P. Putnam's Sons, New York, 1984.

Hillier, Bevis, *Austerity Binge: Decorative Arts of the Forties and Fifties,* Clarkson N. Potter, Inc., New York, 1975.

Honan, William H., *Visions of Infamy,* St. Martin's Press, New York, 1991.

Howe, Quincy, (Editor), *The Pocket Book of the War,* Pocket Books Inc., New York, 1941.

Hyams, Joe, *The Flight of the Avenger: George Bush at War,* Harcourt, Brace, Jovanovich, New York, 1991.

Joseph, Major Franklin H., *Far East Report,* The Christopher Publishing House, Boston, 1946.

Kidd, David, *Peking Story: The Last Days of Old China,* Clarkson N. Potter, 1988.

Logan, Malcolm, *The Home Front Digest,* Howell, Soskins, Publishers, New York, 1942.

Miller, Francis Trevelyan, *History of World War II (Armed Services Memorial Edition),* Universal
 Book and Bible House, Philadelphia, Pennsylvania, 1945.

Morella, Joe, Edward Z. Epstein, and John Griggs, *The Films of World War II,* Citadel Press,
 Secaucus, New Jersey, 1973.

Nelson, Derek, *The Posters that Won the War,* Motorbooks International, Osceola, Wisconsin,
 1991.

Nelson, Derek and Dave Parsons, *Hell Bent for Leather*, Motorbooks International, Osceola,
 Wisconsin, 1990.

Pastos, Spero, *Pin-Up: The Tragedy of Betty Grable,* G. P. Putnam's Sons, New York, 1986.

Prange, Gordon W., *Pearl Harbor: The Verdict of History,* Penguin Books, New York, 1991.

Quirk, Lawrence J., *Fasten Your Seatbelts: The Passionate Life of Bette Davis,* William Morrow &
 Co., New York, 1990.

Quirk, Lawrence J., *The Great War Films,* Citadel Press, Secaucus, New Jersey, 1994.

Reynolds, Clark G., *America at War,* W. H. Smith, Publishers, New York, 1990.

Sideli, John, *Classic Plastic Radios of the 1930s and 1940s,* E. P. Dutton, New York, 1990.

Siegel, Alan A., *Smile: A Picture History of Olympic Park 1887–1965,* American Impressions,
 Plainfield, New Jersey, 1983.

Simon, George T., *Glenn Miller (and his orchestra),* Thomas Y. Crowell Co., New York, 1974.

Sinclair, Andrew, *War Like a Wasp: The Lost Decade of the Forties,* Hamish Hamilton, London,
 1989.

Terkel, Studs, *The Good War: An Oral History of World War II,* Pantheon Books, New York, 1984.

Trilling, Diana, *Reviewing the Forties,* Harcourt, Brace, Jovanovich, New York, 1978.

Uslan, Michael, *America at War: The Best of DC Comics,* Simon and Schuster, New York, 1979.

Valant, Gary M., *Vintage Aircraft Nose Art,* Motorbooks International, Osceola, Wisconsin, 1988.

Woll, Allen L., *The Hollywood Musical Goes to War,* Nelson Hall, Chicago, 1983.

Special Publications

Movie Lot to Beachhead, Editors of *Look Magazine,* Doubleday, Doran & Co., Garden City, 1945.

The U.S. Army in World War II, Volume I, II, III, compiled by the Center for Military History, United States Army, Artabras Publishers, New York, 1990.

The War In Outline: Fighting Forces Series, Infantry Journal, Washington, D.C., 1944.

This Fabulous Century: Volume V, Editors of Time-Life Books, Time-Life Books, New York, 1969.

Calendars

America's Heros: World War II, A Lou Reda Production, Schellmark, Inc., Hackettstown, New Jersey, 1992.

Today in World War II, text by Candace Floyd, concept Don Rieck, Abbeville Press, New York, 1991.

Periodicals

Useful Objects in Wartime, The Bulletin of the Museum of Modern Art, 2 Volume 2, Dec. 1942–Jan. 1943.

Wartime Housing, The Bulletin of the Museum of Modern Art, 4 Volume IX, May, 1942.

Index

★ ★ ★

Page numbers in italic indicate illustrations.